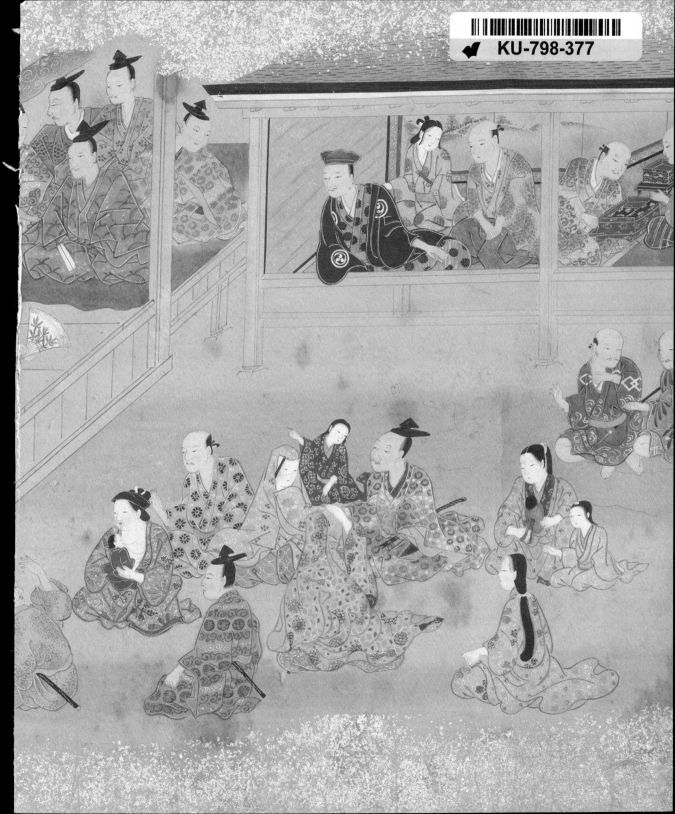

The Chester Beatty Library
BOOK OF DAYS

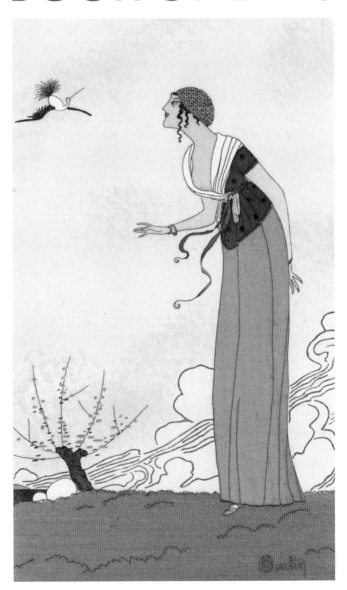

Gill Books

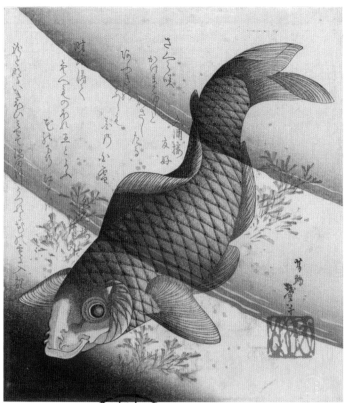

Carp Swimming Among Waterweeds

By Katsushika Taito II. Probably 1832, Japan.

At the time Beatty formed his collection of Japanese *surimono*, there was relatively little interest in these privately commissioned poetic prints. Others had previously recognised the quality of these works, however. This refined *surimono* by Katsushika Taito II once belonged to the prominent French collector and connoisseur, Louis Gonse (1846–1921), author of *L'art Japonais.*

Title page: **Spring Dress (from *Journal des Dames et des Modes*)** By Charles Martin (1848–1934). 1913, France.

This spring scene depicts a woman in a crêpe de chine day dress and embroidered satin jacket. The graphic lines of the clouds in the background are complimented by the flowering tree and whimsical appearance of the bird. Charles Martin belonged to an informal group of artists in Paris known as the 'Knights of the Bracelet' in reference to their fashionable and flamboyant dress and lifestyle. Martin's fashion and interior illustrations were very popular because of their charm and humour.

Gill Books
Hume Avenue, Park West, Dublin 12
www.gillbooks.ie

Gill Books is an imprint of M.H. Gill & Co.

© Text / illustrations: Chester Beatty Library 2018

978 0 7171 8046 2

Design by Tony Potter
Print origination by Teapot Press Ltd

Printed in the EU

This book is typeset in Gill and Zapf Humanist

The paper used in this book comes from the wood pulp of managed forests. For every tree felled, at least one tree is planted, thereby renewing natural resources.

5 4 3 2 1

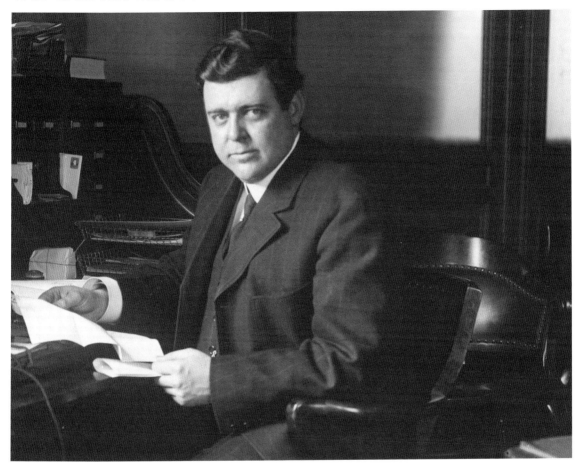

Chester Beatty c. 1911.

Sir Alfred Chester Beatty (1875–1968) was an extraordinary friend to Ireland. Mining magnate, philanthropist and one of the most successful businessmen of his generation, he is today best remembered for the extraordinary collection of rare books, manuscripts and decorative arts that he assembled from across Europe, the Middle East, North Africa and East Asia. Today the Chester Beatty Library is a vibrant national cultural institution situated within the grounds of Dublin Castle, where it is enjoyed by over 370,000 visitors a year from all over the world.

Born into a middle-class New York family in 1875 on the site of what is now the Rockefeller Center, Chester Beatty was the youngest of three sons. On his father's side both grandparents were Irish while his mother was from a long line of colourful pioneers the earliest of whom arrived in 1650. His father was a successful banker and stockbroker and the family had a position in local society.

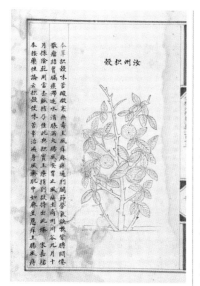

The Great Encyclopaedia of the Yongle Reign *(Yongle Dadian)*
1560s, China.

The Library holds three Ming-dynasty volumes from the celebrated Yongle encyclopaedia. The original edition of this literary encyclopaedia was commissioned in 1403 by the Yongle Emperor (r. 1403–25). Today, this magnificent undertaking is known through the mid-Ming Dynasty copy made for the Jiajing Emperor (r. 1522–67). The Yongle work and much of the Jiajing edition were subsequently lost. Today, an estimated 400 of the 11,095 Jiajing volumes survive in libraries around the world.

From his earliest years he showed a keen interest in mineralogy and after a year at Princeton he went on to the Columbia School of Mines, graduating top of his class in 1898. An early family anecdote recalls Chester, as a young boy, already bidding at auction for mineral samples. The die was cast at an early age, and Beatty became a mining professional and lifelong collector. No matter where his career or personal life took him, he continued to acquire: in the midst of business deals, while on holiday with the family, even during two world wars.

In 1914 Beatty founded his own mining company in London, Selection Trust. The First World War delayed expansion of the enterprise, but during the 1920s the business surged forward to become an enormously successful group of companies with interests in many countries. It was in Northern Rhodesia (now Zambia) and the Belgian Congo (now the Democratic Republic of Congo), however, that Chester Beatty's fortune was made when he dared to exploit the copper belt.

It was during this prosperous period that he built the greater part of his collection. A family trip to Egypt early in 1914 stimulated his appetite for Islamic manuscripts. The dry climate suited Beatty, who suffered from the lung disease silicosis, and he and his second wife Edith Dunn (his first wife Ninette had died suddenly in 1911) continued to spend winters there until the outbreak of the Second World War. In 1917, Beatty visited Japan, and this deepened his interest in Chinese and Japanese art. While there, he bought numerous painted albums and scrolls, and in the following years he continued to acquire Chinese and Japanese paintings, snuff bottles and Buddhist scrolls.

By this time, Beatty was also acquiring important Islamic material, including an exceptional collection of illuminated copies of the Qur'an, and Mughal, Turkish and Persian manuscripts. His Western holdings were enhanced by acquisitions of Coptic, Syriac, Armenian and Greek manuscripts. To his Asian holdings he added Tibetan, Thai, Burmese and Sumatran manuscripts. His eye was drawn to richly illustrated material, fine bindings and beautiful calligraphy, but he was also deeply committed to preserving texts for their historic value. He concerned himself only with works of the finest quality, and this became the hallmark of his collection.

In 1950, at the age of 75, Chester Beatty handed over the reins of Selection Trust to his son Chester Jr and relocated to Dublin, taking many by surprise. The reason often cited is Beatty's growing frustration with post-war Britain, not least the defeat of the Conservative Party in the 1945 general election. However, Beatty was also seriously considering long-term plans for his collection. Concerned that it would be dispersed if he were to leave it to a large institution, he found another solution. His purpose-built library on Shrewsbury Road in the leafy suburb of Ballsbridge in Dublin opened in 1953, first for researchers and later to the public.

In 1957 he became the first honorary citizen of Ireland, and in that same year added a gallery to the library to display his collection. He continued to acquire throughout the 1950s and well into the 1960s, adding important Ethiopian manuscripts and Japanese printed material to the collection in these years. When Chester Beatty died in 1968, he was the first private citizen to be awarded a state funeral in Ireland. His will provided for the continuance of his library as a public charitable trust, supported by the State.

The latest chapter in the history of the collections began when the Chester Beatty Library reopened in 2000 in its new location: the eighteenth-century Clock Tower building of Dublin Castle. Nestled in the centre of the city, the move has brought the Library and its exquisite collections closer to the people of Ireland and the many visitors to this country. Beatty, who never shied away from making bold decisions, would surely have approved. With the support of the Irish State, and the enduring affection of the Irish people, the Library continues to grow in profile and popularity.

www.cbl.ie

Fionnuala Croke
Director

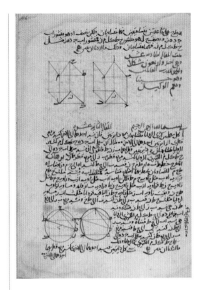

Ishaq ibn Hunayn's Arabic translation of Euclid's Elements (*Tahrir Uqlidis*), 1270, Iraq.

Apart from the many beautifully decorated Qur'ans, the Library holds over 2,500 Arabic manuscripts covering all aspects of Islamic civilisation, many of them unique and only found in the Library's collections. Some are early translations into Arabic of the works of the ancient Greeks and this bound manuscript contains one of the most influential of all Hellenistic works, Euclid's *Elements*.

1st

2nd

3rd

4th

5th

6th

7th

Mount Fuji from Lake Ashi in Hakone By Katsushika Hokusai (1760–1849). Late 1820s, Japan.

Mount Fuji often appears on *surimono* prints prepared for the New Year. It was believed that to dream of the mountain on the first or second night of the New Year would bring good luck in the coming months. *Surimono* often employed luxurious techniques. Here, Fuji's snow-capped peak is shown in blind embossing, while metallic pigments suggest the sun's rays filtering through the clouds.

舞雲雀
声も
高根と
丈くらべ

桂花

熨斗目ほと
霞む裾野や
春やけ不二

二橋

8th

9th

10th

11th

12th

13th

14th

Four Gospels 1655, Iran.

The Armenian collection in the Library is especially rich in manuscripts of the 15th to the 17th centuries, written in the monasteries around Lake Van (Turkey) and near Isfahan (Iran). This gospel book was written by the scribe Hakob and illuminated by the artist Hayrapet (active from 1615 to the 1680s) for the priest Grigor. The patrons of the manuscript paid ten gold pieces for the illumination, and the strong, bright colours used here, with a predominance of yellow, blue and lilac with gold highlights, create a sumptuous effect.

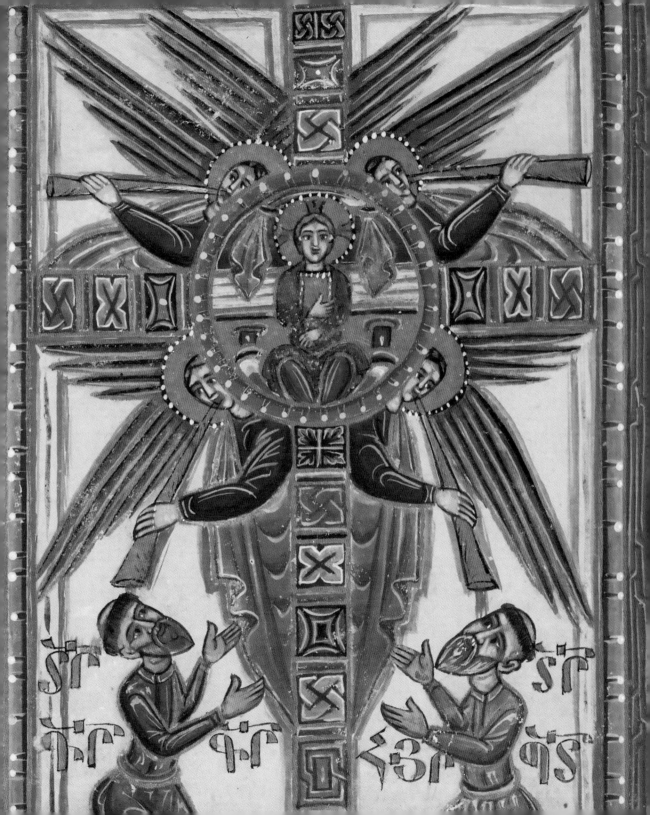

15th

16th

17th

18th

19th

20th

21st

Mary (Maryam) Shakes a Palm Tree to Provide Food for the Baby Jesus (Isa) (from The Tales of the Prophets *(Qisas al-anbiya)***)** 1570–80, Iran.

Known to Muslims as Maryam, Mary is the most prominent female figure in the Qur'an and the only one identified by name. It is said that as soon as Mary touched a dead palm tree, it sprang to life, a feat symbolised in this image by the half-dead, fruit-bearing tree. To the right of the tree lies a tightly swaddled, newborn Jesus, his whole upper body engulfed by a flaming halo.

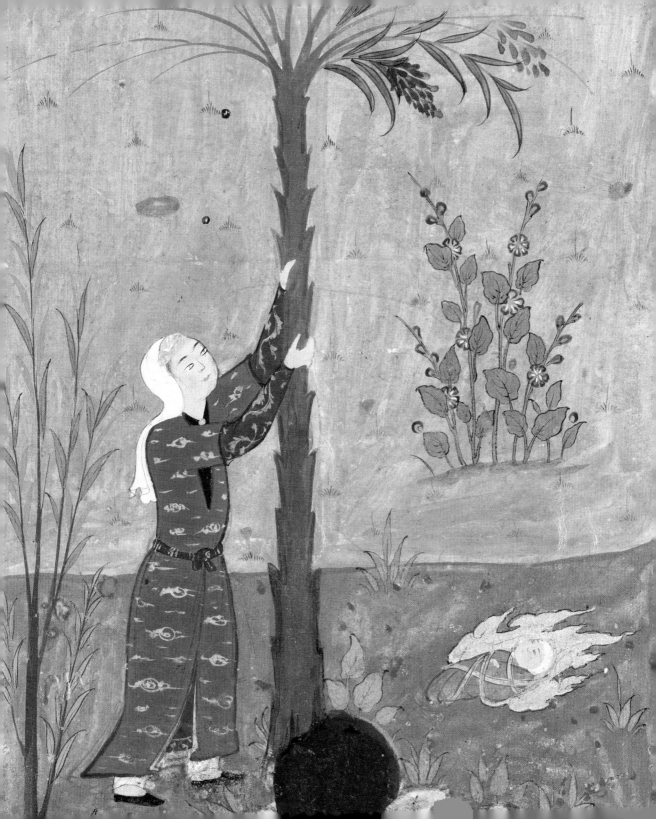

22nd

23rd

24th

25th

26th

27th

28th

It is Good to Dress in New Clothes (from Series for the Hanazono Group) By Totoya Hokkei.
c. 1824, Japan.

A young woman welcomes the New Year with an elegant new outfit of silk brocade in this privately commissioned *surimono* print. The looped style in which she wears her hair is one that was fashionable a century before this print was made, lending it a nostalgic air, while the printmaker's use of embossing and metallic pigments enrich the fabrics depicted.

人よりもりさくら
まく染の衣取易
そむる葉の山姫

仙府
柳水亭
袖住

著そめる
霞のさきぬる
孩猶の
空に〱〱る

全
千柳亭

ひろそ〱めう

北
渓

29th

30th

31st

This month's memorable events

Qur'an, one half of a double-page frontispiece Undated, but probably 1570s, Iran.

The Library's Islamic Collections contain more than 260 Qur'ans and Qur'an fragments and is one of the most important collections of Qur'ans outside the Middle East. In this detail from the right half of a double-page frontispiece, the beginning of the first *sura* (chapter) of the Qur'an, entitled *al-Fatiha* (The Opening) is inscribed in the centre.

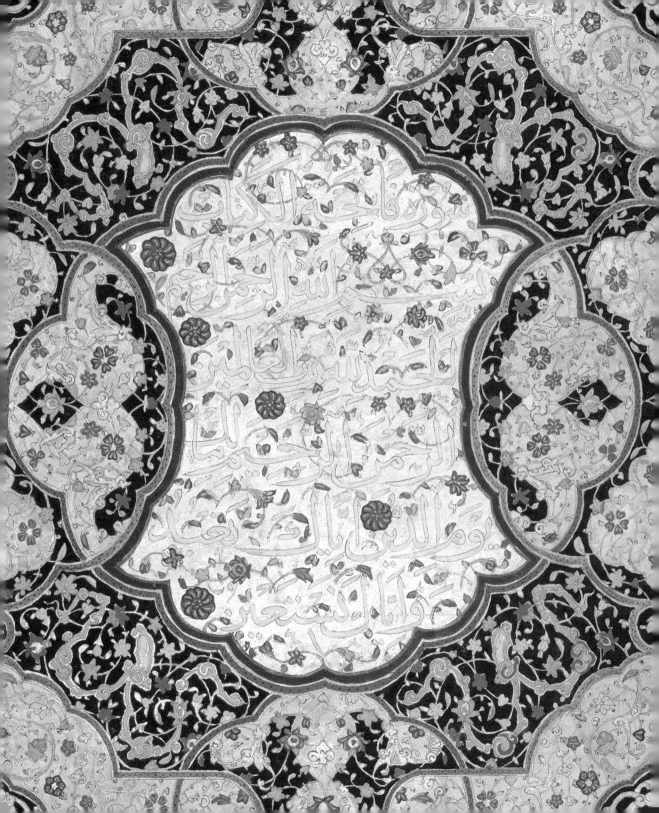

1st

2nd

3rd

4th

5th

6th

7th

The Darani of the One Million Pagodas (Hyakumant Darani) c. 768, Japan.

This miniature wooden pagoda *(tō)* is one of one million *(hyakuman)* commissioned by the Empress Shōtoku (718–770) and distributed to Japan's ten major temples. The pagodas were created to commemorate and offer thanks to Buddhist deities for their help in suppressing the Emi Rebellion of 764. Each contained a printed Buddhist invocation called a *darani* that was rolled up and inserted into the pagoda's hollow core.

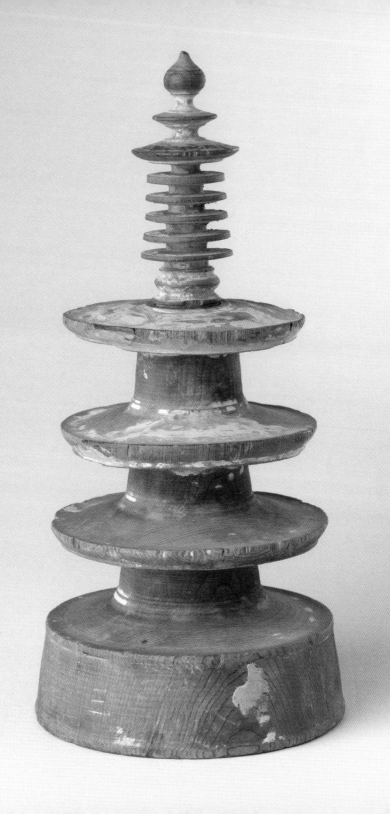

8th

9th

10th

11th

12th

13th

14th

Dragon Robe Qing dynasty (1644–1911). c. 1820–60, China.

The dragon robe was worn by members of the imperial family and high-ranking court officials for semi-formal occasions and official business. Clothing was carefully regulated at the Qing court, and the colour and decoration of garments were employed to indicate rank. Yellow robes decorated with five-clawed dragons over waves were reserved for the emperor, the crown prince wore an apricot robe, and the emperor's sons wore golden-yellow.

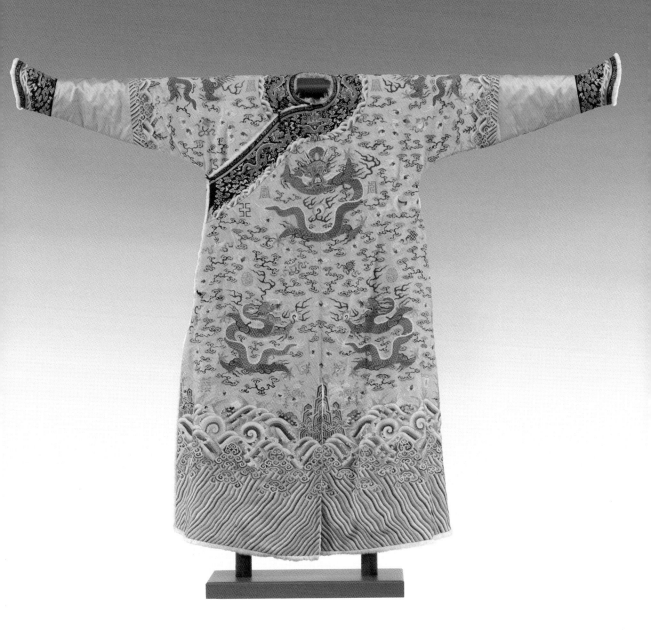

15th

16th

17th

18th

19th

20th

21st

Book of Kings *(Shahnama)* of Firdawsi 1655, Iran.

The poet Firdawsi's *Shahnama* (Book of Kings) is one of the great classics of world literature. Widely referred to as the Iranian national epic, it relates the glorious tales of the heroes and kings of Iran, from the dawn of time until the Islamic conquest in the mid-7th century. This miniature captures a moment during Iskandar's (Alexander the Great, 356–323 BC) lengthy funeral cortège. The *Shahnama* tells us that Iskandar's troops 'shrouded their king in golden brocade, lamenting as they did so, then placed him beneath a covering of Chinese silk' before placing him in a golden coffin.

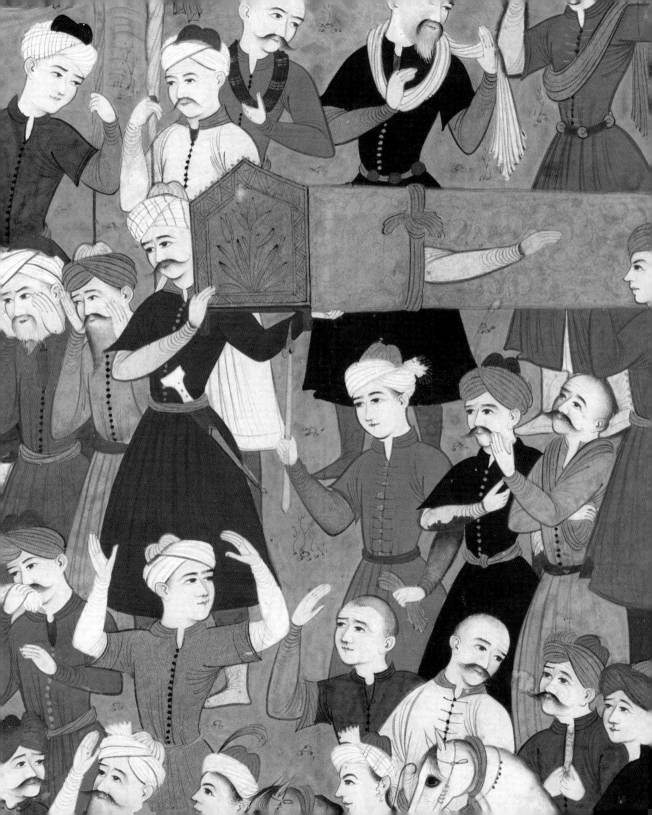

22nd

23rd

24th

25th

26th

27th

28th

Cuneiform Tablet c. 2200–2100 BC, Mesopotamia.

Over four thousand years old, this clay writing tablet carries an early example of the written language in the cuneiform writing system. The text refers to a measure of butter: on the face of it not a subject of startling significance, until we learn that it was an offering for the moon god Su'en (or Sin). Revered by the inhabitants of Lagash, Su'en, whose name dates back to the very beginning of written documentation, was one of the most important deities in Mesopotamia.

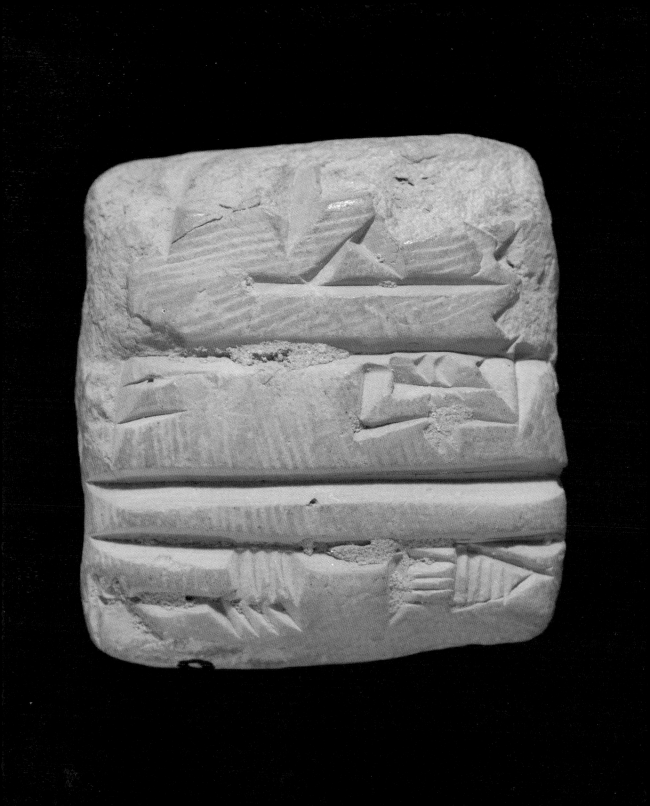

29th *leap year*

This month's memorable events

The History of Akbar *(Akbarnama)* c. 1600–03, India.

The Mughal emperor Akbar was one of the ablest and most dynamic rulers of India and although virtually illiterate, he loved books and kept the court studio continually busy producing manuscripts for him. In this miniature, another aspect of the emperor's personality is portrayed: his intense curiosity about other religions. The first Jesuit mission sent to Akbar arrived in 1580, and in this painting, two Jesuits attend one of the emperor's debates.

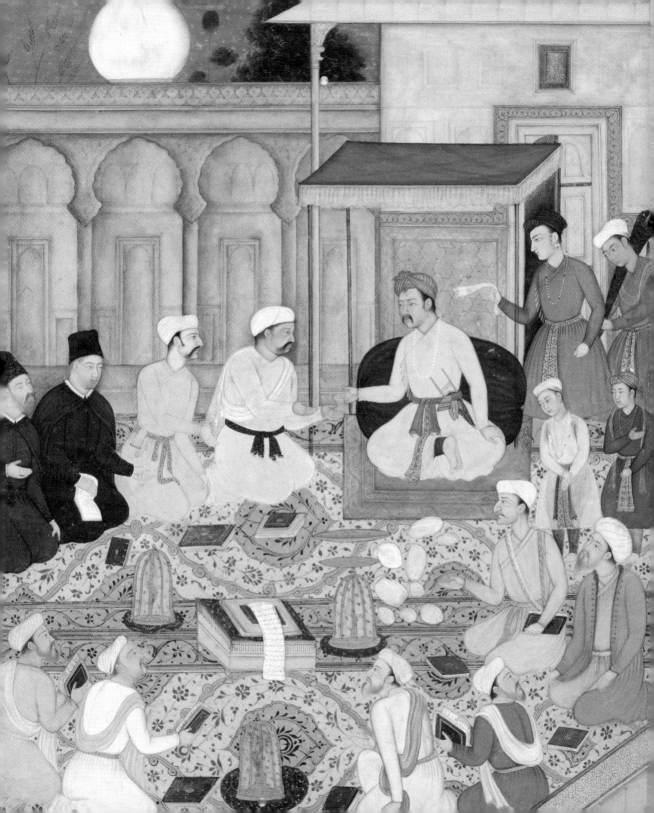

1st

2nd

3rd

4th

5th

6th

7th

The Tale of the Bamboo Cutter *(Taketori Monogatari)* Early 17th century, Japan.

The Tale of the Bamboo Cutter is said to be the oldest work of prose fiction in Japanese literature. Chester Beatty's scrolls, which date to the early 17th century, are believed to be the earliest surviving illustrated version. The story centres on an old bamboo cutter, the 'shining princess' he discovers in a stalk of bamboo, and her five suitors. The narrative unfolds over two scrolls through panels of elegant calligraphy interspersed with painted scenes.

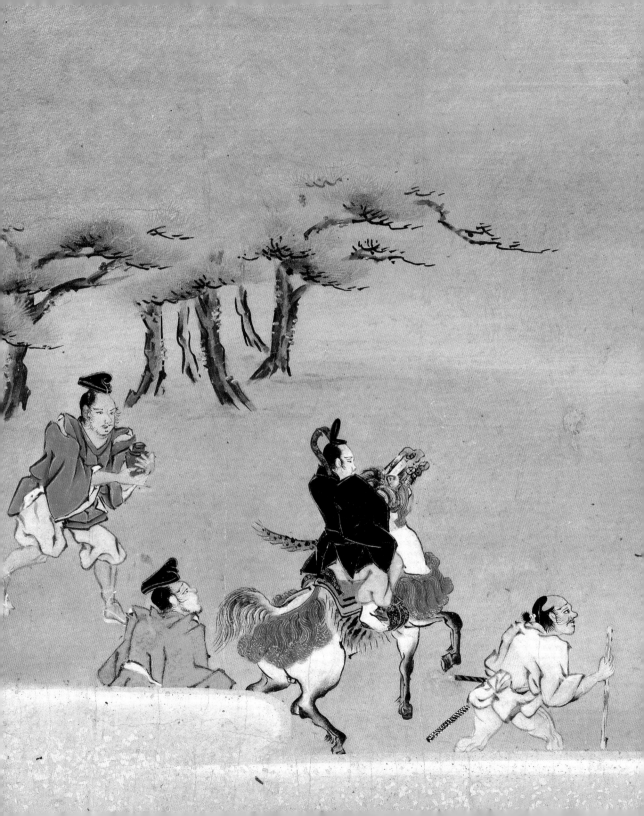

MARCH �֍ MÁRTA

8th

9th

10th

11th

12th

13th

14th

Group of vellum bindings 16th & 18th centuries, Rome, Paris and Madrid.

Although the word vellum can be used to describe any animal skin prepared for use in manuscripts, it refers specifically to the skin of a young calf. Islamic book makers adopted paper well before their European counterparts and, because of this, the majority of the vellum in the collection was produced in Europe. In addition to being used as a writing surface, vellum has also been used for many centuries as a bookbinding material. There are numerous examples of vellum in the collections, used both as a writing surface and a binding material.

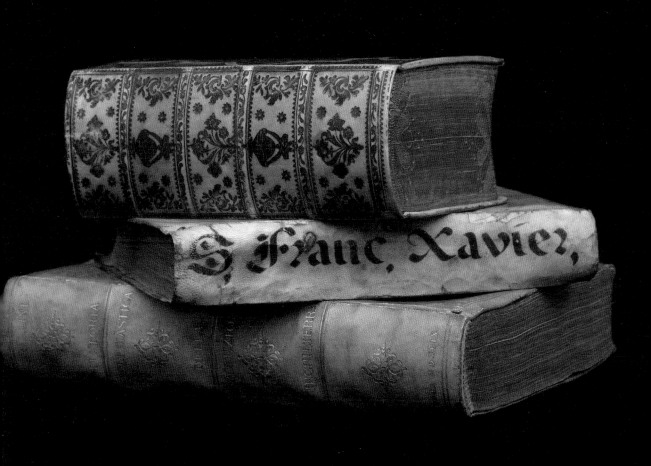

15th

16th

17th

18th

19th

20th

21st

The Actor Ichikawa Danjūrō VII Preparing to Inscribe a Fan By Utagawa Kunisada (1786–1864). Mid-1820s, Japan.

Among the 800 Japanese prints collected by Chester Beatty are some 350 *surimono*, a term used to describe privately commissioned prints, frequently created to celebrate special occasions and often intended for private circulation by poetry groups. Kunisada was a friend of Danjūrō VII, the leading *kabuki* actor of the mid-19th century. A poet and calligrapher himself, Danjūrō is portrayed in his dressing room with his writing box open.

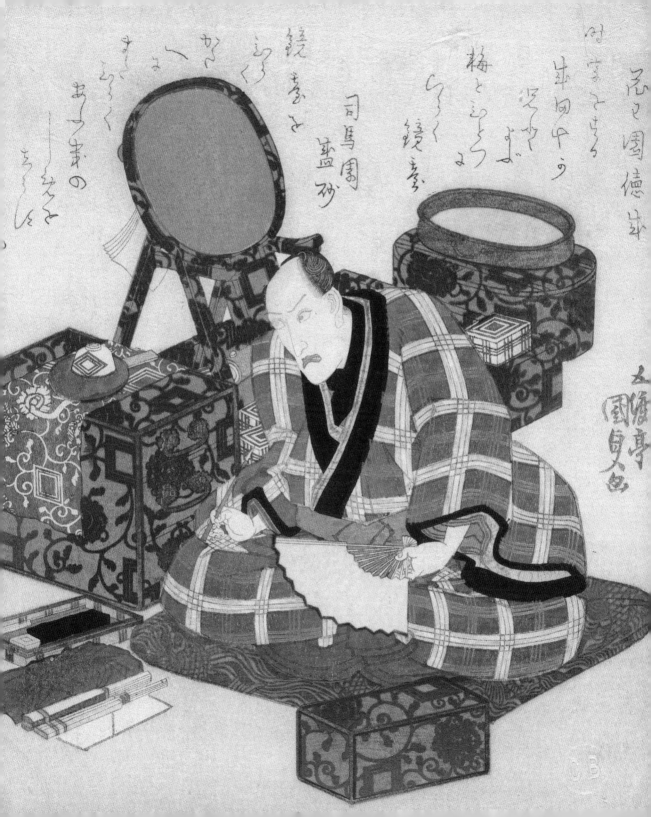

March ❈ Márta

22nd

23rd

24th

25th

26th

27th

28th

Statius' Thebaid c.1380, Italy.

Beatty's wife Edith bought this wonderful manuscript as a gift for him in 1925. She paid £7,000 for it, but did so knowing that Chester Beatty considered it 'a beautiful book … of uniformly high grade'. Illuminated with a remarkable miniature painted in grisaille with royal blue skies and a delicate frame of gold and blue, it contains the Latin saga by the 1st-century poet Statius, which has as its theme the deadly strife of the Theban brothers.

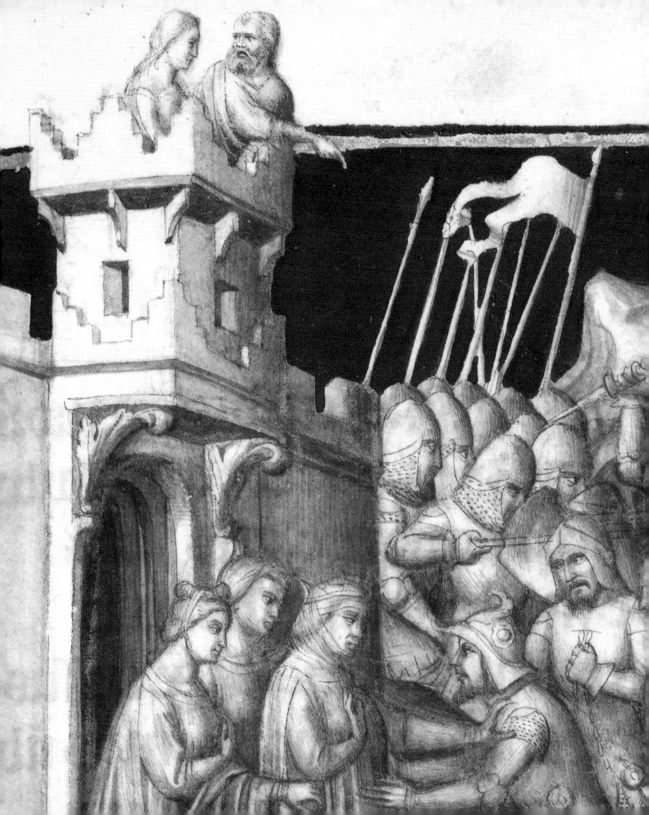

MARCH �֎ MÁRTA

29th

30th

31st

This month's memorable events

Fuji from Musashi Koshigaya (from the series Thirty-six views of Mount Fuji) By Utagawa Hiroshige (1797–1858). 1858, Japan.

A snow-covered Mount Fuji is seen in the distance through the flowering branches of two plum trees in this print by Hiroshige. Famous beauties, *kabuki* actors and city life were the most common subjects in *ukiyo*-e woodblock prints but in the second quarter of the 19th century the repertoire was expanded to include well-known vistas and landscapes.

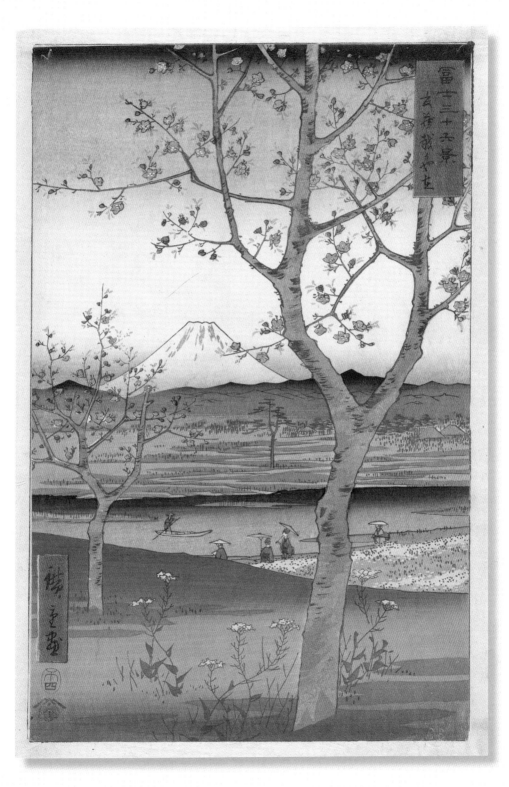

APRIL ❀ AIBREÁN

1st

2nd

3rd

4th

5th

6th

7th

Life of the Buddha 19th century, Burma.

The life of the Buddha was especially popular as a subject for manuscript illustration in Burma – far more so than in other south-east Asian countries. This beautifully illustrated *parabaik* (or folding book) is made of long sheets of paper folded concertina fashion. The events of the Buddha's life can be followed by opening out the leaves from left to right. The covers of this manuscript are of gilded and relief-moulded lacquer and leather.

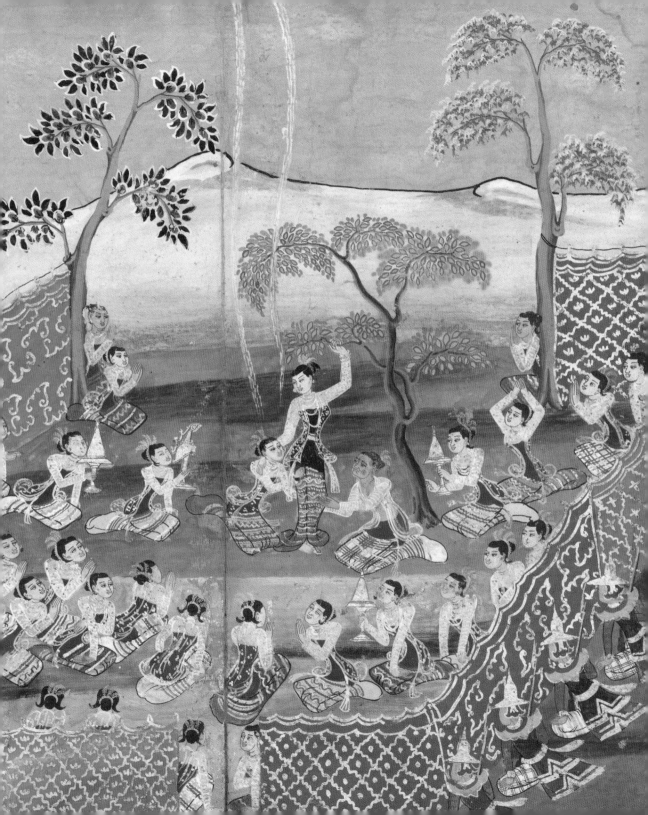

8th

9th

10th

11th

12th

13th

14th

Shiva Riding a Composite Bull c. 1780, India.

The Ganges River flows from the head of the Hindu god Shiva, who is seated on Nandi, the bull that serves as the god's vehicle. Often individual small scenes are being acted out amongst the figures that make up the body of a composite animal, as is the case here with the two musicians by Nandi's neck and the man scratching the neck of his cow on Nandi's belly. Note also Nandi's about-to-be-devoured rabbit feet.

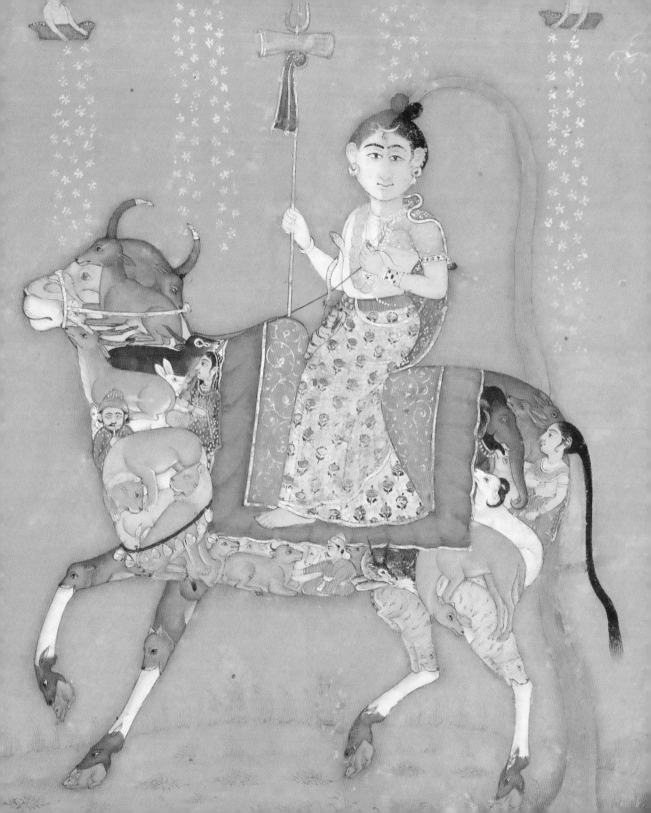

15th

16th

17th

18th

19th

20th

21st

The Miracles of the Blessed Virgin Mary 18th century, Ethiopia.

This beautifully illustrated manuscript contains the Ethiopic text of the Miracles of the Blessed Virgin Mary. In this scene, the artist tells the story of the unfortunate painter who (top left) paints the Virgin in a French church, unaware that the devil is interfering with the scaffolding on which he is perched. As he falls headlong to the ground below (bottom left), he cries out to the Virgin and 'a hand of light came forth' as she rescues him and suspends him in mid-air, so that his feet do not touch the ground.

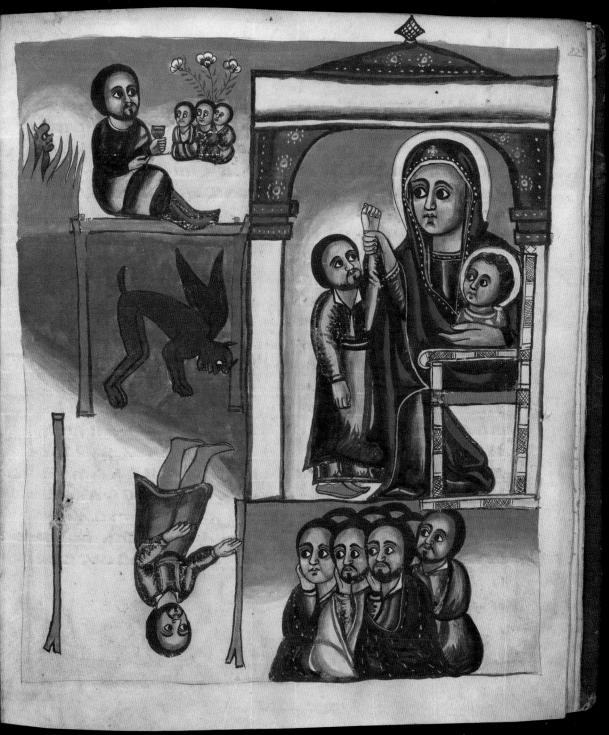

22nd

23rd

24th

25th

26th

27th

28th

Book of Enoch and Homily of Melito 14th century, Egypt.

The Chester Beatty Biblical Papyri is one of the most important collections of early Christian texts so far discovered. It includes manuscripts from as early as the 2nd century and highlights the Christian preference for the codex over the scroll. In this example, a decorative flourish marks the end of 'The Epistle of Enoch' and the beginning of the Passion homily of 'Melito', Bishop of Sardis (d. c. 180). This simple embellishment represents some of the earliest ornamentation of Christian codices.

ΥΠΕΡΙΞΑΝΜΟΙΚΑΙΕ...ΘΗΝΥ
ΤΑΙΟΠΛΑΞΕΝΤΟΥΟΥΡΑΝΟΙΑΓ
ΤΟΕΤΕΘΕΑΝΤΑΕΝΤΕΙΓΑΜ
...ΟΝΟΤΙΑΝΙΕCΕΝΓΑCΚΑ
ΚΝΙΘΥΔΩΝΤΟΥΕΜΕΧΡΙCΤΟΥΑΝΟ
CΕΝΕΑΝΑΙΚ...ΟΥΝΗCΚΑΙΗΚΑ
ΛΕΙΤΝΚΑΙΗΑΜΑΡΤΙΑΛΛΑCΤΑ
ΗCΚΑΙΑΓΑΘΑΗCΗΕΠΙΠΗCΗ
ΠΑΥΤΟΥCΚΑΙΝΥΝΑΠΟΠΡΕΧΕΙΑΤΕΚΝ
ΚΑCΗΜΑΙΝΟΝΑΑΜΩCΤΟΥΙCΟΥ
ΤCΕΔΑΙΟΝΤΟΥΤΟΤΟΙCΝΗΘΕΝΤΕΚΝΟ
ΑΥΤΟΥΕCΤΙΔΑΙΚΑΙΟΟΔΙΟΥΨΕΥΔΟCΚΑΙΟ
CΗΚΟΥCΑΝΛΛΑΔΟΥCΑΛΕΚΤΟΥCΝΔΙΟΥC
ΝΩΧΤΟΥCΠΕΑΥΤΟΙCΜΥCΤΗΡΙΑΚΩC
ΑΡΕΞΙΛΑCΕΝΑΥΤΟCΚΑΙΕΚΛΗCΗΘΟΟ
ΝΩΑΛΛΑΥΤΟΥΝΗCΕΙΡΕΝΟΝΤΗΝΗΝ
ΔΙΟΤΗCΑΤ...ΕΧ

ΕΠΙCΤΟΛΗ
ΕΝΩΧ

ΜΕΛΛΩΝ

ΗΜΕΡΑΤΟ...ΗΤΙCΒΡ...ΚΗCΘΕΕΔΟ...Ε
ΕΝΩCΟΤΑΙΚΑΙΤΑΡΗ...ΑΤΟΥΜΥCΤΗΡΙΟΥΔΙ
ΔΟCΕΦΑΗΛΑΤΩ...ΟΤΠΡΟΒΑΤΟΝΘΙΕΤΗΚΑ
ΠΩCΔΛΟCΟΟΖΙΤΑΝΝΟΝΗCΥΝΤΑΙΔ
ΤΑΤΙΤΟΓΟΥΤΩCΟΤΙΝΙΑΙΝΟΝΚΑΙΠΑ
ΟΝΑΤΙΩΝΙCΛΗΠΡΟ...ΔΡΟΝ...
...ΕΕΡΤΟΝΘΝΙΤΟΝΤΑΛΛΟΝ
ΤΟΥ...ΚΑΛΙΥCΤΗΡΙΔΙΠΑΛΑΙ
ΚΑΙΤΟΝΝΟΜΟΝΚΑΙΝΟΝΔC
ΛΟΙCΠΡΟCΚΑΙΝΟΙCΚΑΤΑΤΟ
ΔΙΝΗΔΙΑΤΩΝΝΧΑΝΗ...
ΤΟΥΠΡΟΒΑΤΟΥCΤΑCΗΛΑΠΡΟC
ΤΟΥ...ΟΥΗΝΟΝΤΗΝΛΛΑΠ
...ΟΡΕΝΑΘΑΝΑΤΟΝ...
...ΝΑΙΤΗΝΠΛΑΝ...
...ΛΓΟ...ΚΑ...

29th

30th

This month's memorable events

The Bodhisattva Jizō 15th century, Japan.

Chester Beatty spent four months in Japan in the spring of 1917. During this visit, he became interested in Japan's Buddhist arts, acquiring sutras and hanging scrolls. This scroll depicts the bodhisattva Jizō. The protector of travellers and guardian of children and of those who have to suffer in the underworld, Jizō is one of the most popular deities in Japanese Buddhism. He is portrayed as a youthful monk, carrying a wish-fulfilling jewel and his six-ringed monk's staff.

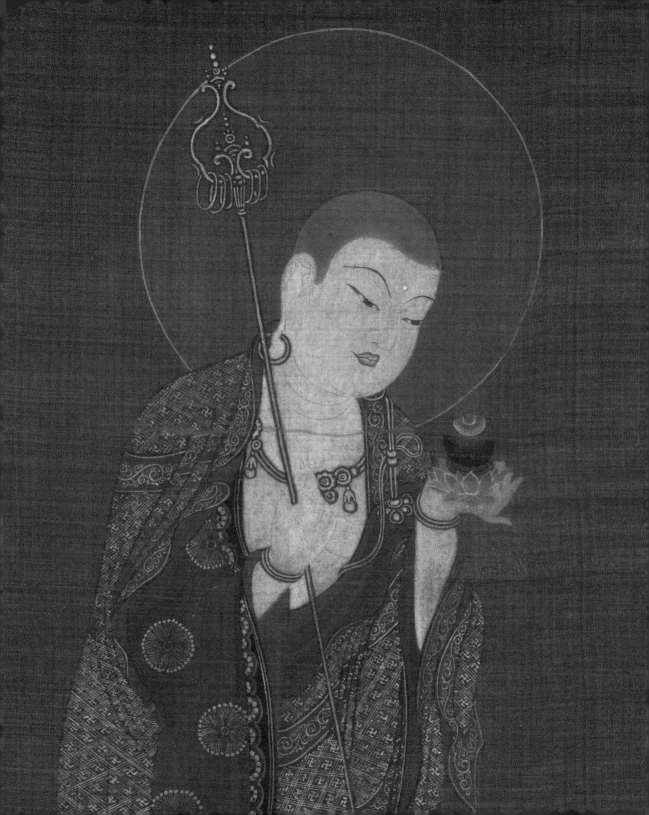

MAY ❀ BEALTAINE

1st

2nd

3rd

4th

5th

6th

7th

Group of jade snuff bottles 18th–19th century, China.

Jade is considered to be the most powerful and mystical material used in Asian art, comparable to gold, silver and diamonds in the West. Admired for its sheen, beauty, smooth surface, strength and durability, in China jade has long been associated with longevity and wisdom as well as imperial authority. Chester Beatty was fascinated by minerals since childhood: his collection comprises more than 950 snuff bottles, all from the Qing period (1644–1911), and many of them made of jade.

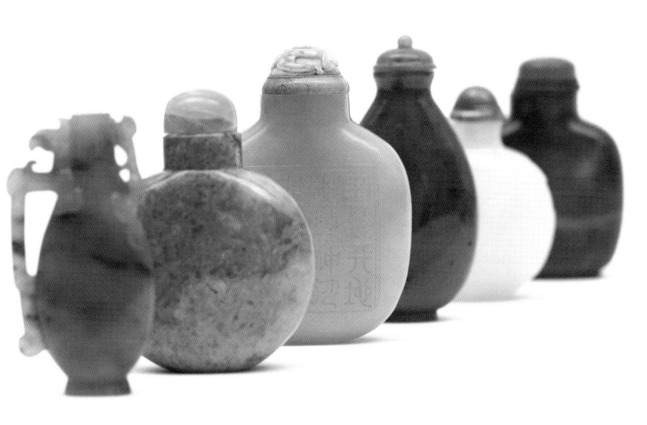

MAY �֍ BEALTAINE

8th

9th

10th

11th

12th

13th

14th

Iskandar Oversees the Building of the Wall 1550–60, Iran.

In Islam, Iskandar (Alexander the Great) is revered as both a great king and a prophet. When, during his travels to the ends of the earth, his protection is sought against the Yajuj and Majuj people (Gog and Magog), he orders a wall constructed to keep them at bay. Although not normally part of the story, the artist has depicted a group of *divs* (or demons) assisting in this task.

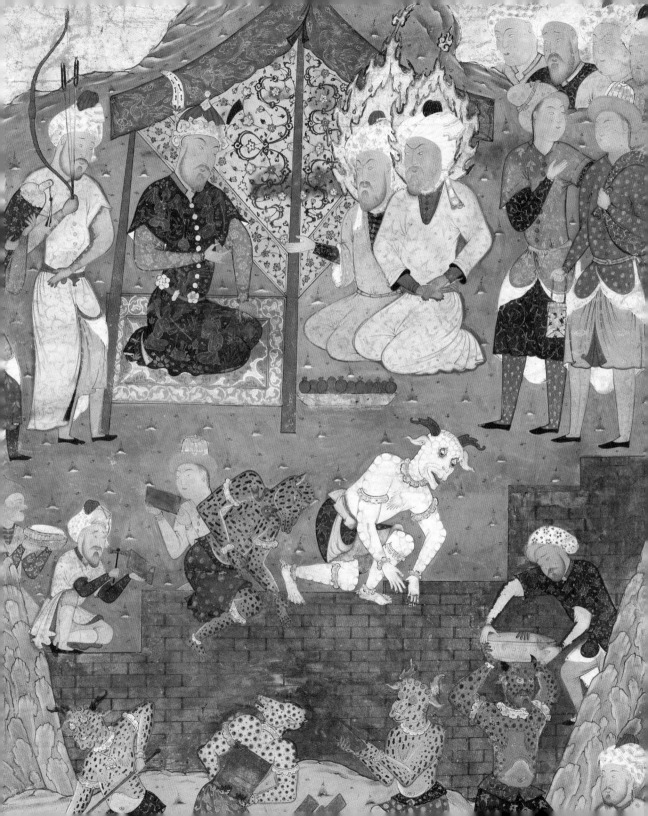

15th

16th

17th

18th

19th

20th

21st

Military rank badge, Third Rank: Leopard 19th–20th century, China.

In China, embroidered symbols on clothing indicated status and endowed the individual with protective or auspicious properties. Military officials wore square badges decorated with brave and ferocious animals appropriate to their rank. Other auspicious motifs were also used on these rank badges, such as flaming jewels, bats or *lingzhi* fungus, which were thought to bring long life and good fortune.

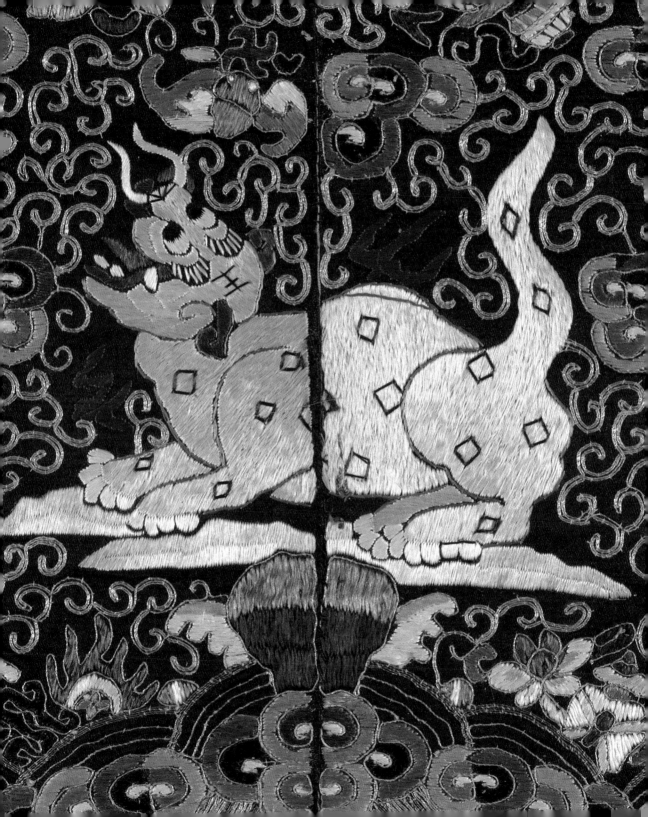

22nd

23rd

24th

25th

26th

27th

28th

The Song of the Jade Bowl: A Poem by the Qianlong Emperor 1745, China.

The treasures of the Chester Beatty Library include 15 jade books produced in the jade factory of the Chinese imperial court. The making of jade books enjoyed a revival in the 18th century thanks to the patronage of the scholar–emperor Qianlong. No fewer than ten of the Library's jade books are inscribed with texts composed by Qianlong himself, while four reproduce his handwriting.

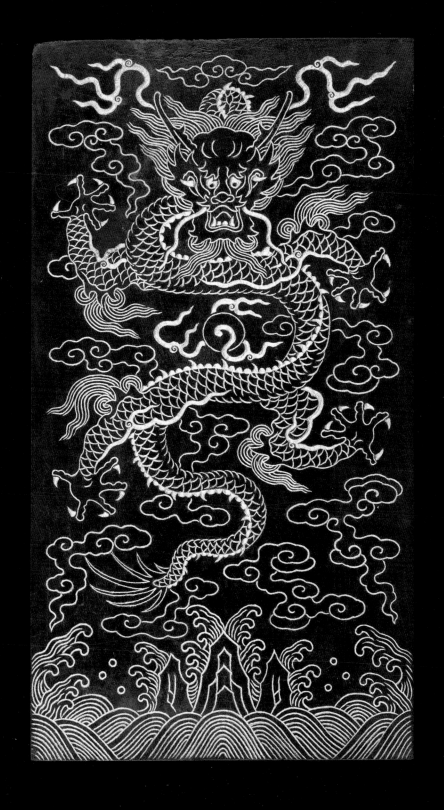

29th

30th

31st

This month's memorable events

The most famous islands of the world *(L'isole più famose del mondo)* By Thomaso Porcacchi (c. 1530–85). 1576, Venice.

This is an early edition of author and cartographer Porcacchi's celebrated description of islands, with numerous illustrations throughout by the Paduan engraver Girolamo Porro (c. 1520–1604). The work contains an early map and description of the four provinces of Ireland, and of the dress of its inhabitants.

DESCRITTIONE
DELL'ISOLA D'HIBERNIA,
OVERO D'IRLANDA.

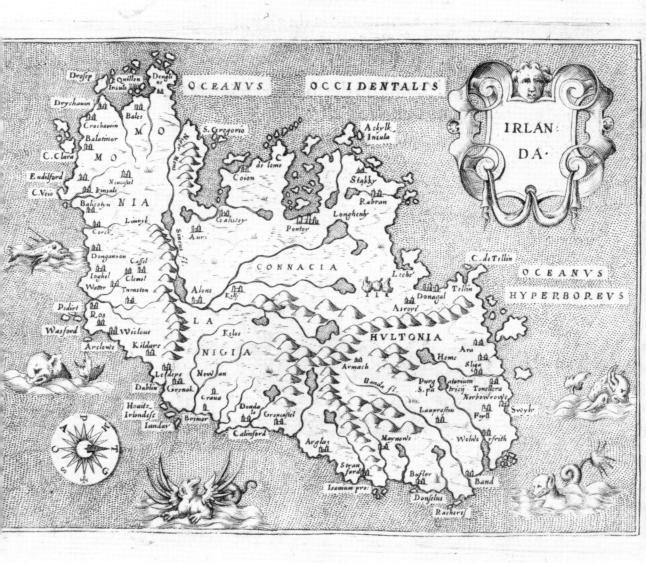

June ✣ Meitheamh

1st

2nd

3rd

4th

5th

6th

7th

Phylactery (amulet) 16th century, Armenia.

An amulet is a small object usually worn on the body to protect the wearer from various evils, dangers and afflictions. This example includes an explanation of the apocryphal Letter of Abgar, written from Jesus to Abgar V of Edessa (4 BC–AD 50). Legend has it that the letter cured the King of his illness, helped him resist the Persian invasion and aided in the conversion of his kingdom to Christianity. The Library has a vast array of amulets produced for people of different beliefs from around the world.

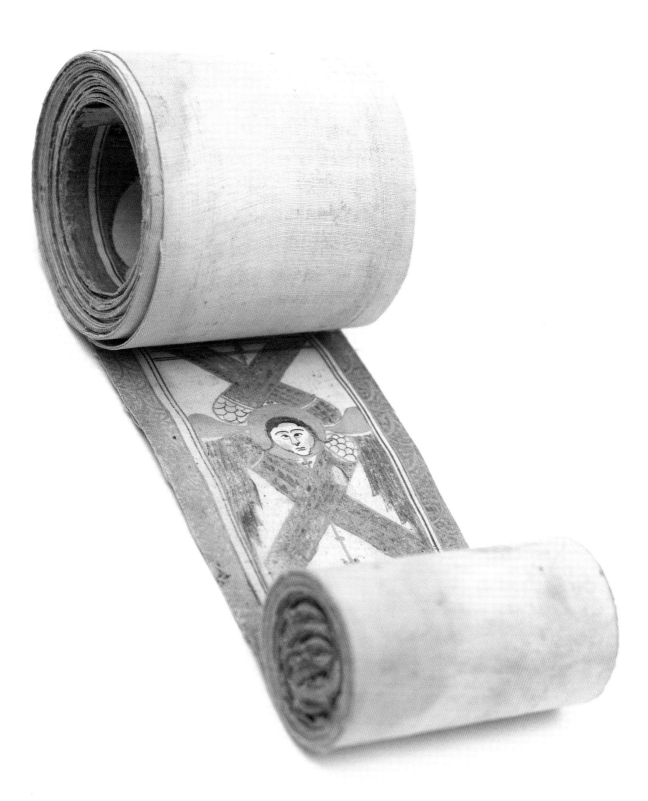

8th

9th

10th

11th

12th

13th

14th

Emperor Awrangzib Receives Prince Mu'azzam c. 1707–12, India.

Awrangzib (r. 1658–1707) is depicted as one would expect a king to be portrayed: formally and solemnly seated upon a throne of gold encrusted with precious gems, wearing robes made of richly embroidered or brocade fabrics and bedecked in strings of pearls and rubies. A jewelled parasol – a symbol of royalty – helps shield him from the sun, while a magnificent golden halo confirms his status as divinely sanctioned monarch.

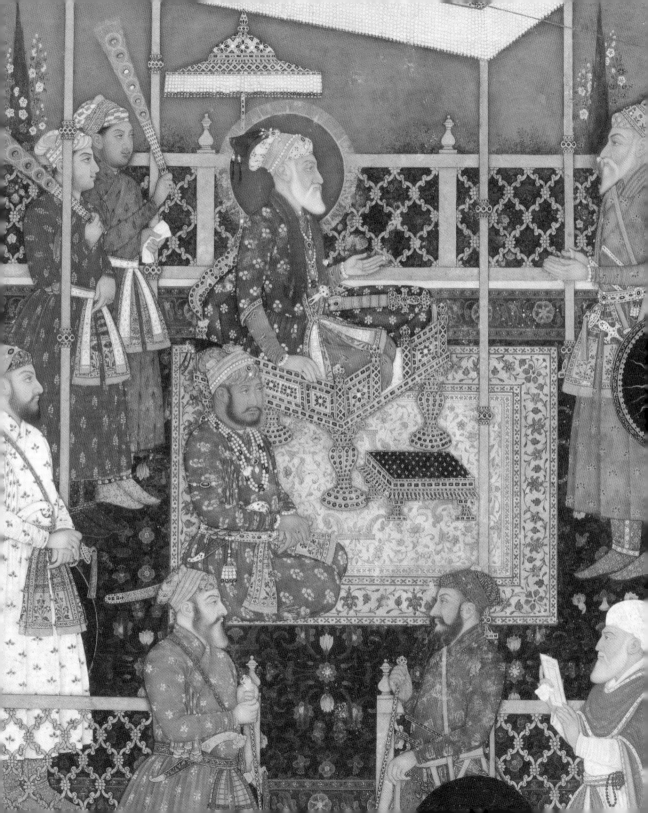

15th

16th

17th

18th

19th

20th

21st

Incense box with a monkey holding a peach 19th century, Japan.

Richly decorated lacquer boxes were used for both treasured objects and more everyday functions in Japanese society. Varying in size and shape, such boxes were often intended for a specific purpose. As with tea ceremony and flower arrangement, the enjoyment of incense had developed into a complex pastime by the Edo period (c. 1603–1868).

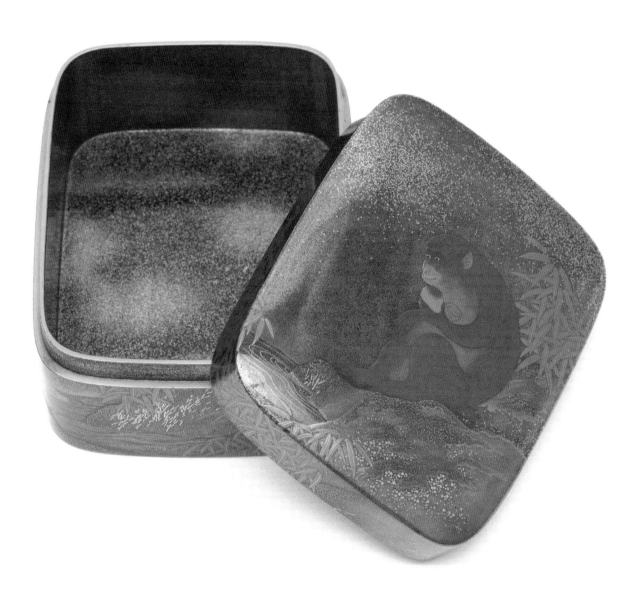

22nd

23rd

24th

25th

26th

27th

28th

'Coiffure of Madame de Korff' 1791, Paris.

Throughout the French Revolution (1789–99), satirical prints were published, of which the Library has a considerable collection. This anonymous cartoonist has satirised the attempted escape of the royal couple through Montmédy when the Queen travelled under the name Madame de Korff (de Caoffre) with the King as her valet de chambre. Louis acts as the Queen's coiffeur; her hair was often the subject of ridicule because it was linked to the extravagant sums she spent on fashion.

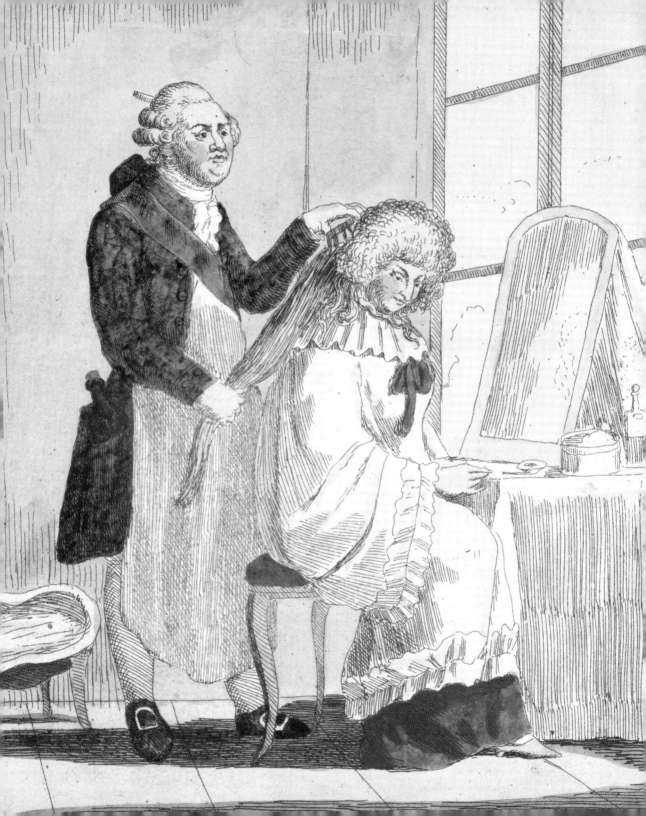

29th

30th

This month's memorable events

A Lady Prepares a Meal c. 1810, India.

The dramatic colouring and the rhythmic and stylized flow of the woman's clothing combine to create an extremely striking image. Painted in Kangra, in the Himalayan foothills, the painting is equally notable for being a genre scene. The artist has chosen to depict a woman at an everyday task, instead, as was more usual at the time, of depicting a woman as the subject of love or beauty.

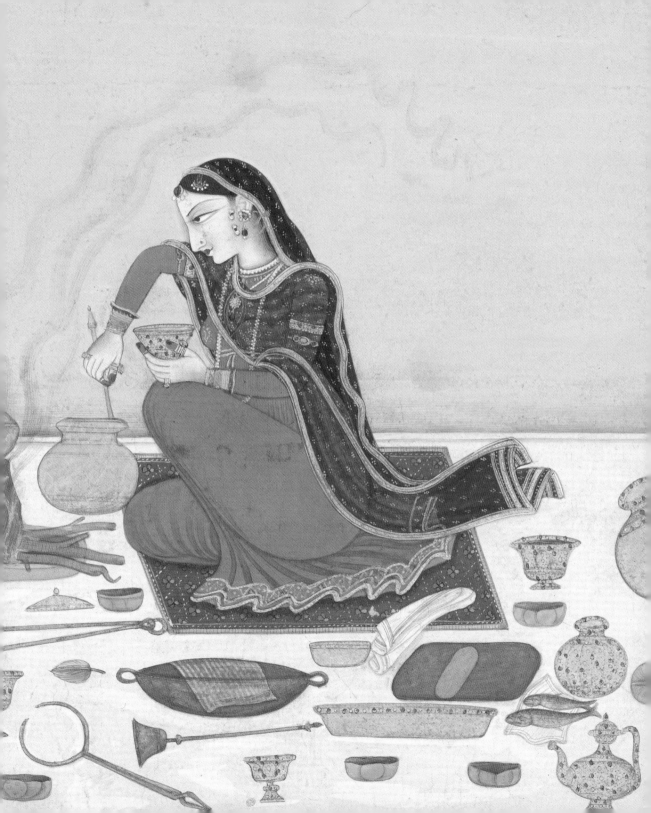

JULY �֎ JÚIL

1st

2nd

3rd

4th

5th

6th

7th

The Rose Garden *(Gulistan)* **of Sa'di** 1426–27, Herat (present-day Afghanistan).

This copy of the famous *Gulistan* (Rose Garden) of Sadi, the 13th-century Persian poet, was produced for Baysunghur (1397–1433), a prince of the Timurid dynasty and a great patron of the arts of the book. In this scene, the poet recalls an episode from his own youth. As he walked down a street on a scorching summer's day, he was overcome with heat and paused in the shadow of a wall. As he did so, a beautiful girl appeared in the doorway of a house and offered him a refreshing drink.

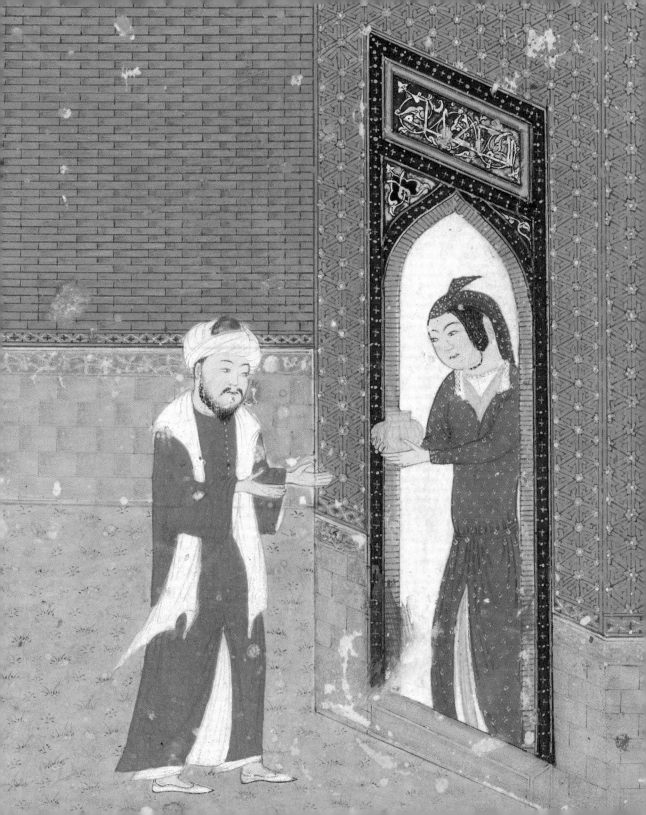

8th

9th

10th

11th

12th

13th

14th

Summer Dress *(from Journal des Dames et des Modes)* By Victor Lhuer (1876–1951). 1914, France.

Victor Lhuer was a specialist in costume and *haute couture* design. In addition to his work in fashion illustration, he was a designer for one of the leading *couturiers* of the day, Paul Poiret, and later became the furrier to the Queen of England. This plate contains a design for a light cotton dress trimmed with sky blue linen, suitable for an afternoon in the garden.

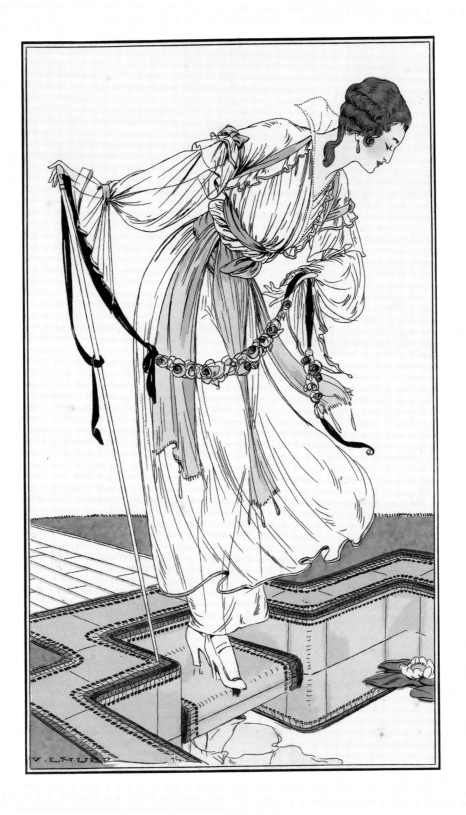

July ✳ Júil

15th

16th

17th

18th

19th

20th

21st

Harmonia macrocosmica By Andreas Cellarius (*fl.* 1656–1702). 1661, Amsterdam.

Also known as the *Atlas Coelestis*, this collection of celestial maps is renowned for the beauty of its 29 hand-coloured and illuminated double plates. The first 21 describe the astronomical theories of Ptolemy, Copernicus and Tycho Brahe and feature the signs of the zodiac as still in use today.

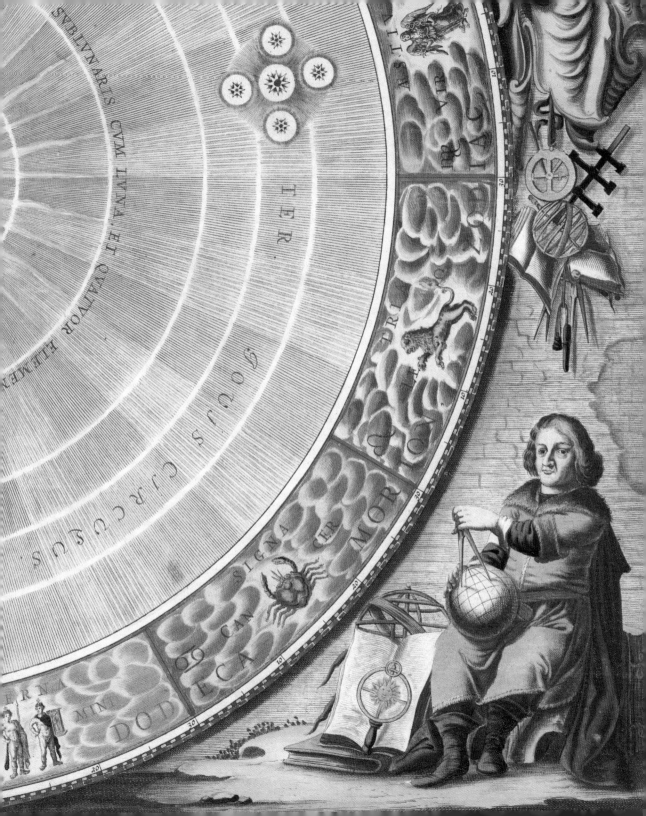

22nd

23rd

24th

25th

26th

27th

28th

Noah (Nuh) and the Ark (from The Cream of Histories *(Zubdat al-tawarikh)***)** Late 16th century, Turkey.
The story of Nuh (Noah), his building of the ark and of the flood, is told in considerable length in the Qur'an, in particular in Chapter 71, which bears the title 'Nuh' and deals exclusively with his story. In this image, Noah is clearly distinguished from the other men on the ark by his greater size and haloed head. Many of the animals he has saved are visible through the arched windows in the mid-section of the ark.

29th

30th

31st

This month's memorable events

Martyrdom of St Stephen (from Coëtivy Hours) Attributed to the Dunois Master. 1444, France.

Produced for private devotion, Books of Hours were the best-sellers of late medieval Europe and one of the treasures of Chester Beatty's collection is the *Coëtivy Hours,* bought by Edith Beatty as a gift for her husband. In this miniature, we see the first Christian martyr, Stephen, depicted as a young, beardless man with a tonsure and deacon's vestments. He was accused of blasphemy by the Jewish authorities and subsequently stoned to death.

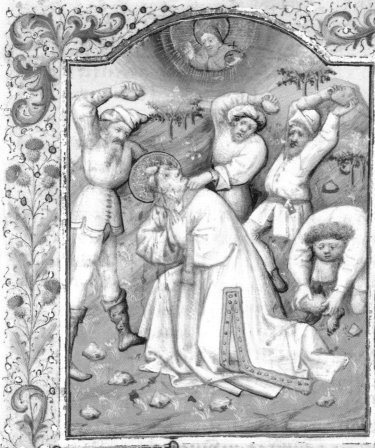

De senior Stephane
Due martir unicdore
qui inter agmma ple
bie Judice fumus

1st

2nd

3rd

4th

5th

6th

7th

Frontispiece of a Qur'an c. 900, possibly Syria.

Decoration was introduced gradually into the design of Qur'ans. Ornaments separating verses and chapters came first, and later full-page frontispieces appeared. This beautiful early folio is the left-hand side of what was once a double-page frontispiece that, at some point in its long history, was detached from its parent manuscript.

AUGUST �֎ LÚNASA

8th

9th

10th

11th

12th

13th

14th

The Old Man Encounters a Youth (from The Five Poems *(Khamsa)* **of Amir)** 1485, Iran (present-day Afghanistan).

The thirteen illustrations in this manuscript of the Five Poems *(Khamsa)* of Amir Khusraw Dihlavi are attributed to Bihzad, renowned as the greatest of all Persian painters. He worked in Herat (then part of Iran) at the court of the Timurid ruler Husayn Bayqara, who appointed him head of the royal atelier, a position previously held only by calligraphers.

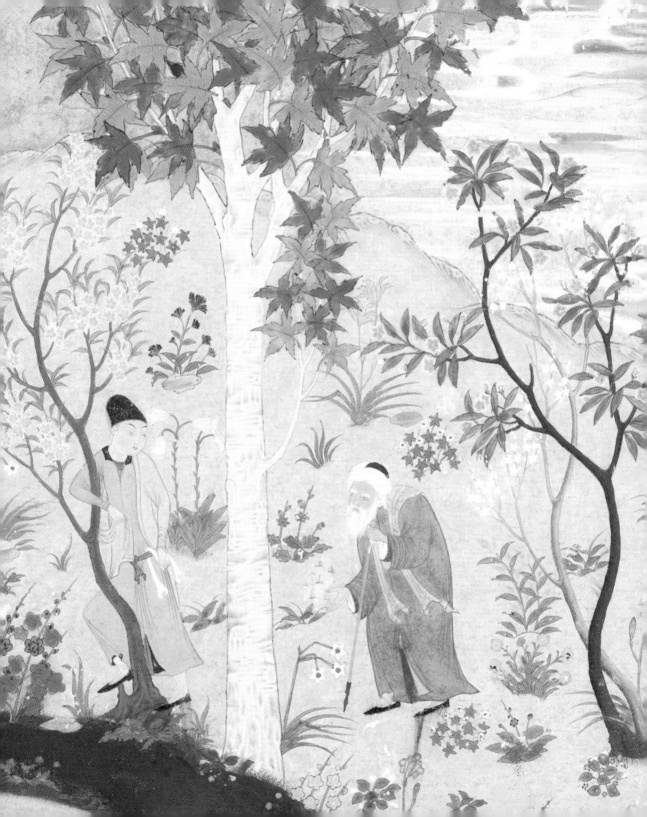

AUGUST �֍ LÚNASA

15th

16th

17th

18th

19th

20th

21st

The Story of Yoshitsune's Invasion of Hell *(Yoshitsune Jigokuyaburi)* Mid-17th century, Japan.

This legend of the famous warlord, Minamoto no Yoshitsune (c. 1159–89), tells how the hero and his followers conquered the underworld. In this scene, Yoshitsune's loyal companion Benkei splits open the head of a demon, while Yoshitsune looks on in heavy armour, holding a fan. The small figure in the foreground is an ascetic. Later it is revealed that the story played out is merely his dream.

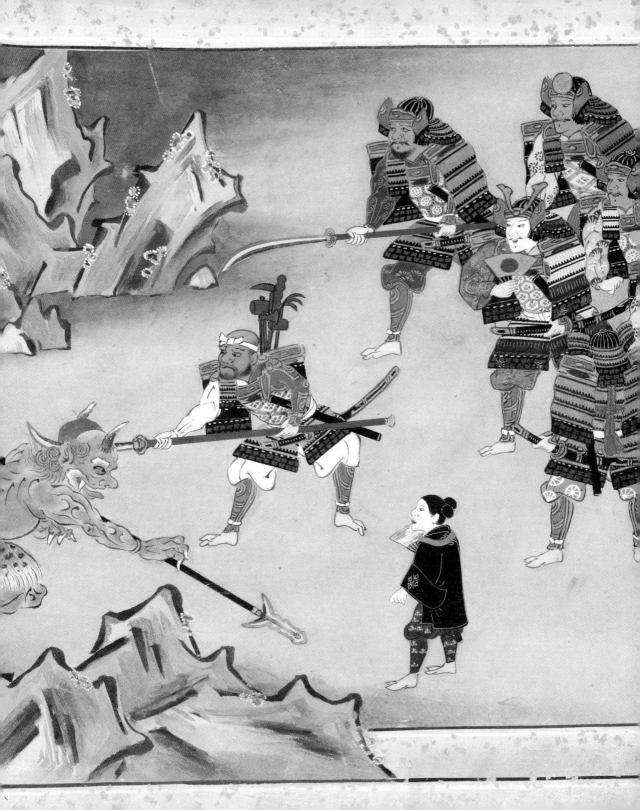

August ❀ Lúnasa

22nd

23rd

24th

25th

26th

27th

28th

Hand-Drums of Ten Thousand Years *(Banzei no Tsuzumi Emaki)* Mid-17th century, Japan.

Emerging as a distinctive form in the 14th century, Noh *(nō)* is not only the earliest fully developed theatrical genre in Japan, but one of the oldest living dramatic forms in the world. The first scene of the Noh play *Okina* ('The Old Man') is depicted here. The artist captures the layout of the Noh theatre: the lead actor, wearing an elaborate robe and mask and holding a fan to accentuate gestures, performs with musicians and singers in front of a seated audience.

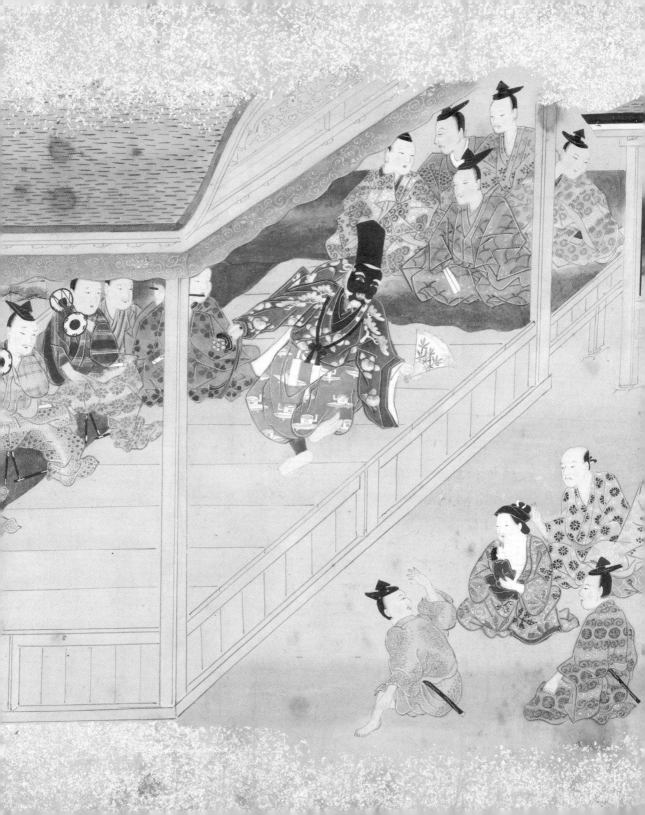

August �֍ Lúnasa

29th

30th

31st

This month's memorable events

A Dancer Balances a Bottle c. 1770, India.

'As far as the eye can see' is the phrase that immediately springs to mind when looking at this beautiful painting. The main event may be the young woman in the foreground dancing while deftly balancing a full bottle on her head, but it is the enclosed gardens spread out behind her that catch the eye, drawing it farther and farther into the distance.

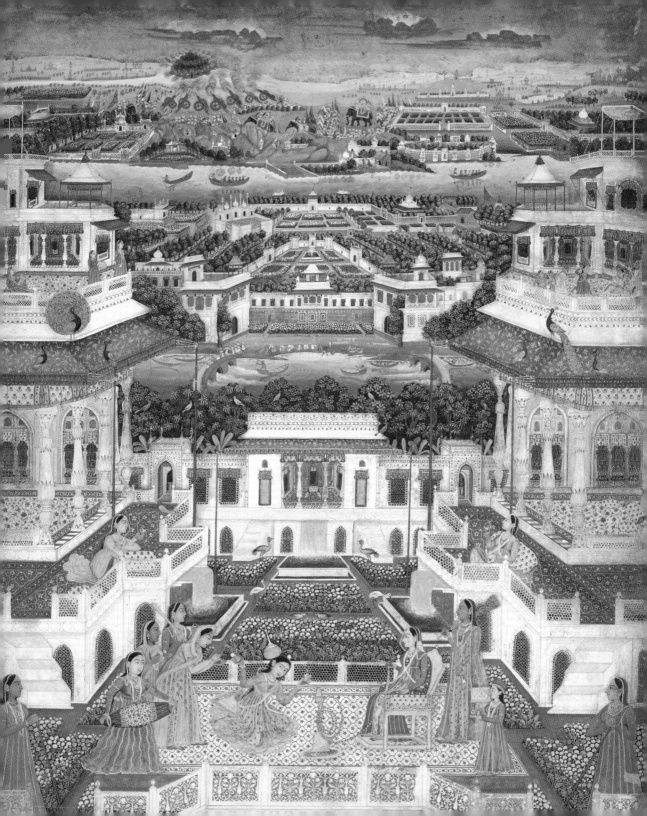

September ❊ Meán Fómhair

1st

2nd

3rd

4th

5th

6th

7th

The Chester Beatty Library Dublin By Wilfred René Wood (1888–1976). Dated September 1952.

Chester Beatty moved into his new home on Ailesbury Road in Dublin in May 1950 and in June the same year he acquired a site on nearby Shrewsbury Road where he built a library to house his collection. This delightful watercolour, dated September 1952, shows the completed complex. During Beatty's first summer in Ireland his wife, Edith, died in London and although the couple had not lived together for several years, they had remained on close personal terms. A trifling but telling detail is that Edith entrusted her dog to her husband's care, and surely this is the small white terrier accompanying Beatty in the picture.

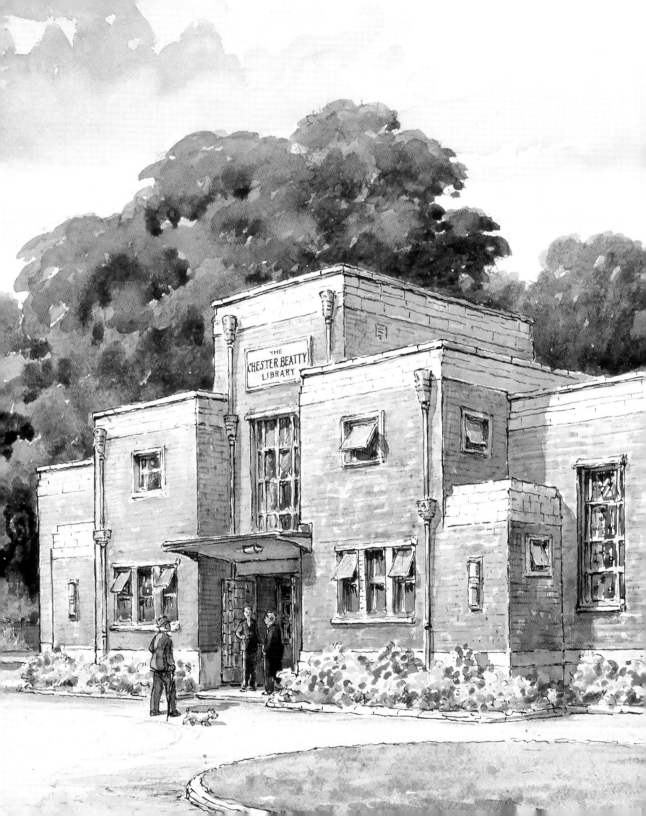

September ✳ Meán Fómhair

8th

9th

10th

11th

12th

13th

14th

The Prester John of the Indies *(Ho Preste Joam das Indias)* By Francisco Alvares (c. 1465–1541). 1540, Portugal.

This full-page woodcut introduces Francisco Alvares' rare account of a Portuguese diplomatic mission of 1515 to the court of Ethiopian Emperor Lebna Dengel. Dengel was believed by many Europeans to be the legendary Christian king, Prester John. Alvares remained at the imperial court for six years, and produced the first detailed account of travel in Ethiopia.

Verdadera informaçam das terras do Preste
Joam/ segundo vio τ escreueo ho padre Francisco Aluarez capellã del Rey nosso
senhor, Agora nouamēte impresso por mandado do dito senhor em casa de Luis
Rodriguez liureiro de sua alteza.

15th

16th

17th

18th

19th

20th

21st

Chester Beatty at the Dolores gold mine 1903, Mexico.

From the time he arrived in the Western United States, Chester Beatty had looked forward to visiting Mexico, and the opportunity arose when he was asked to make an examination of the Dolores gold mine in the heart of the rugged Sierra Madre. He travelled as far as he could by train and then another five days on horseback. He had been warned that banditry was still rampant in the more isolated areas of the Sierra Madre and he rode with a rifle across his back and a revolver in his boots!

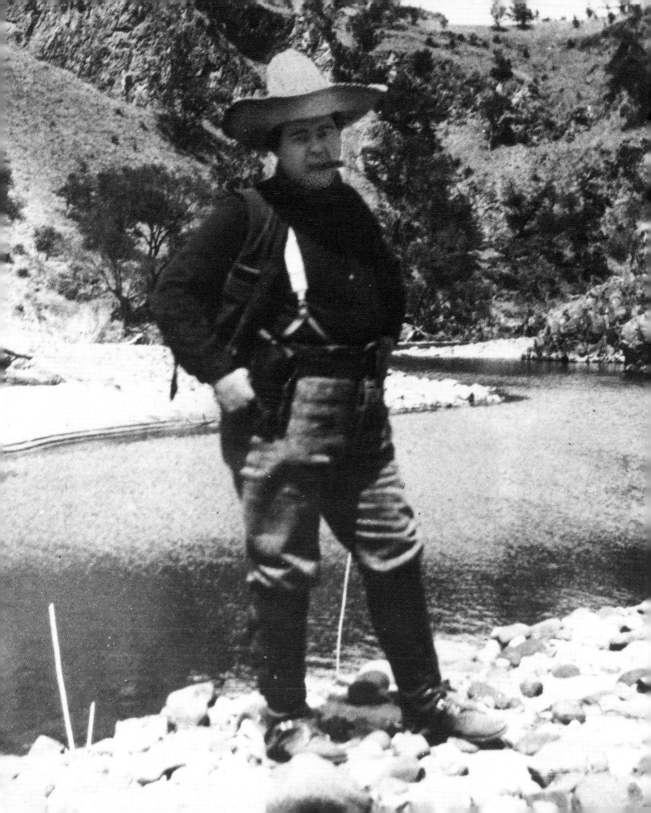

22nd

23rd

24th

25th

26th

27th

28th

Beautiful Women at a Yashiki By Chobunsai Eishi (1756–1829). c. 1795–1800, Japan.

Ukiyo-e literally means 'pictures of the floating world'. As a term it is used to describe Japanese woodblock prints of the 17th to 19th centuries which depicted the 'floating world' of urban pleasures – from beautiful courtesans to *kabuki* actors, and all the other varied pleasures and distractions of the city. This print, however, takes a manor house in the countryside as its focus, capturing the lives of its elegant residents in delicate colours.

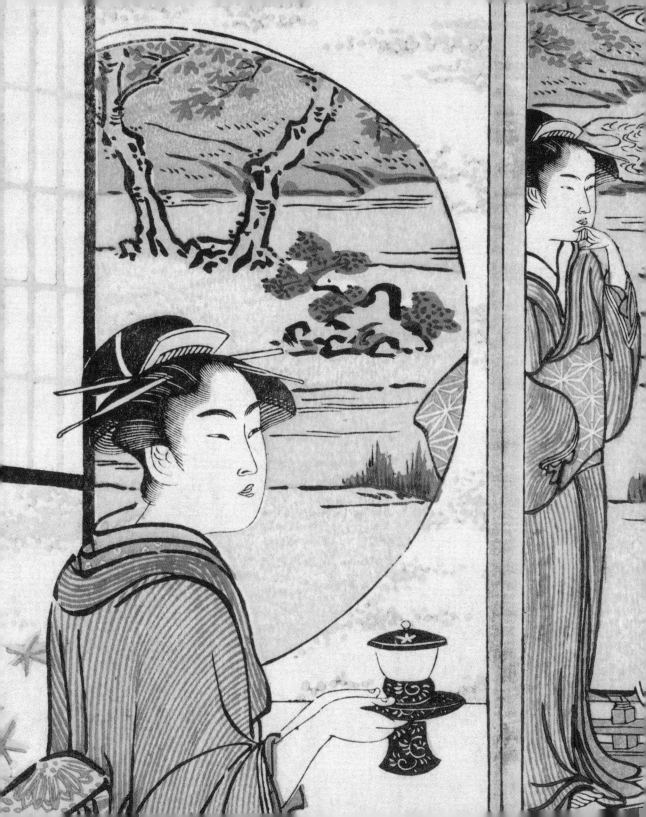

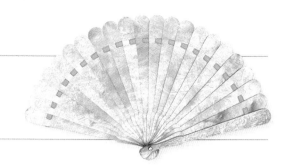

29th

30th

This month's memorable events

Mother-of-pearl brisé fan c. 1830, China.

Brisé or 'broken' fans are folding fans formed from separate tapered sticks. Crafted from mother-of-pearl and intricately carved with scenes of Chinese life, this fan is among the rarest of *brisé* fans. Mother-of-pearl was imported to China from the Philippines at great expense and was a very costly material. It was more commonly used in the manufacture of small items, such as snuff boxes, gaming counters or furniture inlay.

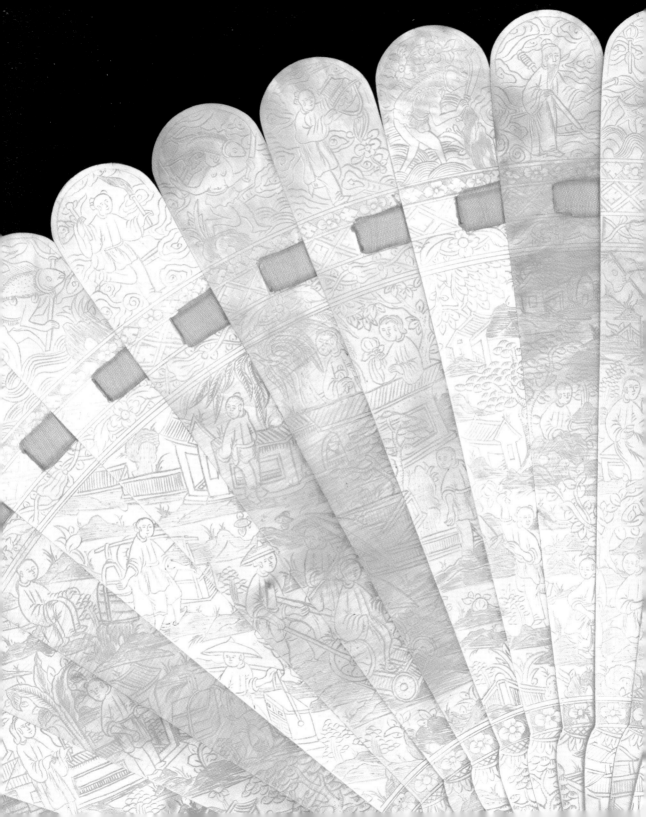

October �֎ Deireadh Fómhair

1st

2nd

3rd

4th

5th

6th

7th

Popish Plot playing cards After Francis Barlow (1626–1704). c. 1679, England.

In the late 17th century, politico-historical playing cards became particularly popular. This set of cards, based on drawings by Francis Barlow, depicts the Popish Plot of 1678. In the midst of heightened hostility towards Catholics in England, Scotland and Ireland, Titus Oates, together with Israel Tong and others, conspired to manufacture a popish plot to assassinate Charles II.

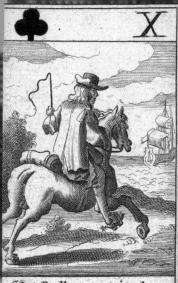

Capt. Bedlow carrying letters
to Forraigne Parts.

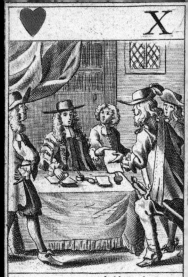

Mr. Langhorn deliuering out
Comiſsions for ſeverall Offic.rs

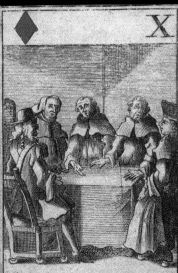

Gavan informe the Fathers of the
affairs in Staffordſhire.

Sr. E.B. Godfree is perſwaded
to goe down Somerſet houſe Yard.

8th

9th

10th

11th

12th

13th

14th

The Life of the Prophet 1594–95, Turkey.

This painting illustrates a scene in the fourth volume of a six-volume *Life of the Prophet (Siyar-i nabi)*. The manuscript was made for the Ottoman sultan Murad III in 1594–95 and is regarded as one of the greatest masterpieces of Ottoman arts of the book. The text was written in the 14th century by Mustafa Dharir (The Blind Man) and recounts the life of the Prophet Muhammad and events from the early history of Islam.

15th

16th

17th

18th

19th

20th

21st

The Simurgh Carries Zal to Her Nest Late 16th century, Iran.

The poet Firdawsi's *Shahnama* (Book of Kings) is one of the great classics of world literature and this dramatic painting depicts the Simurgh, a fabulous, bird-like creature of Persian mythology. This scene features the baby Zal; born an albino and rejected by his father who leaves him to perish on a mountainside, he is swept up by the Simurgh, intending to serve him up as a tasty morsel for her chicks. Instead, she saves him, and raises him in her nest alongside her own offspring.

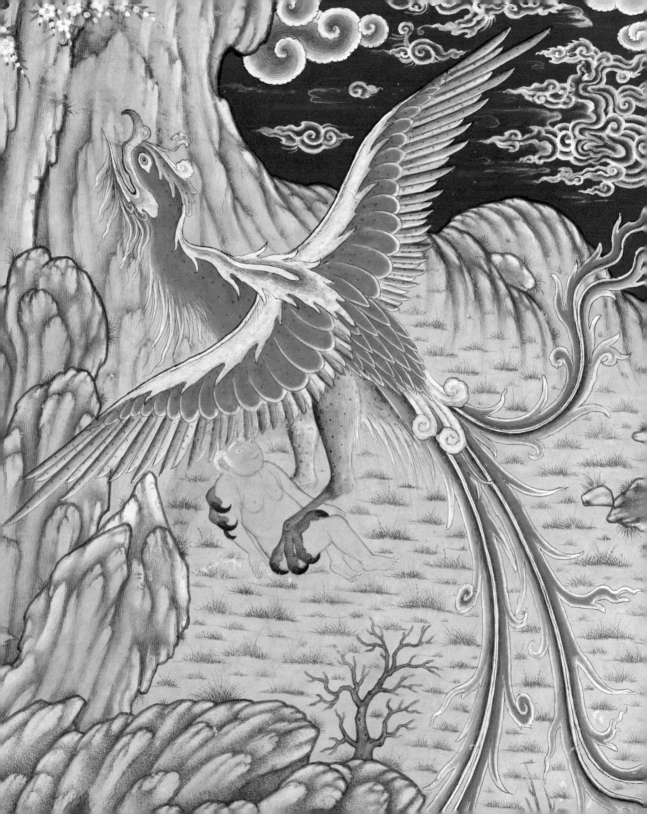

October �֍ Deireadh Fómhair

22nd

23rd

24th

25th

26th

27th

28th

Edith Beatty (1886–1952) By Philip de László (1869–1937). Dated 19 October 1916, England.

Edith Beatty had been married to Chester Beatty for just over three years when she sat for de László in October 1916, at a time when everyone in London, even the privileged, was feeling the pinch of wartime restrictions. There is, however, no hint of this in de László's elegant society portrait, which captures the lovely Edith's blue eyes, high cheekbones and luminous pearls with the artist's usual confident and economic use of the brush.

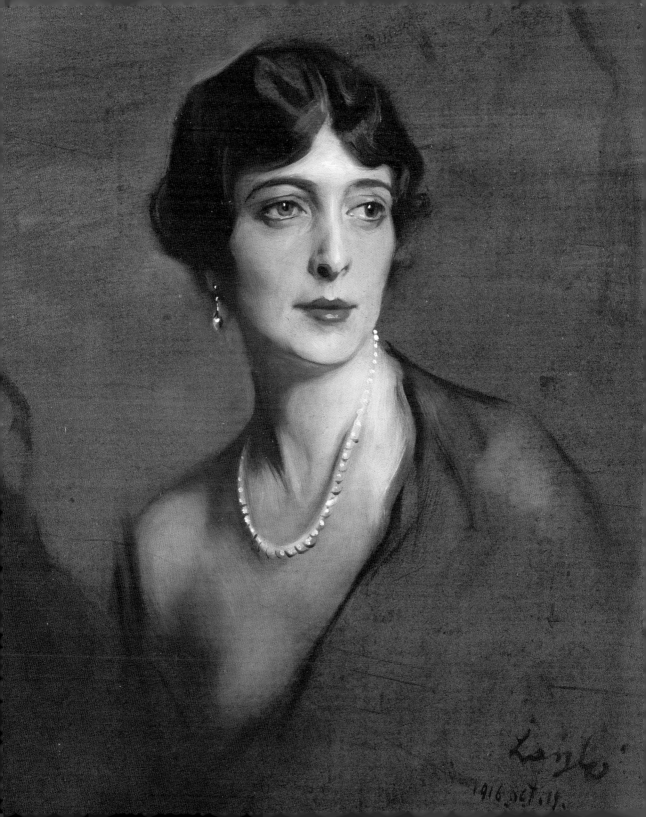

29th

30th

31st

This month's memorable events

Asakusa Ricefields and the Torinomachi Festival (from the series One Hundred Famous Views of Edo)
By Utagawa Hiroshige (1797–1858). 1857, Japan.

The celebrated master Hiroshige was one of the leading designers of landscape prints in 19th-century Japan. In this print a white cat, outlined in the *kimedashi* embossing technique, watches the procession of revellers from the windowsill of a building in the Yoshiwara pleasure quarters. The hostess may be behind the screen; her hairpins rest on the floor while a bowl and towel sit to the side following the morning's ablutions.

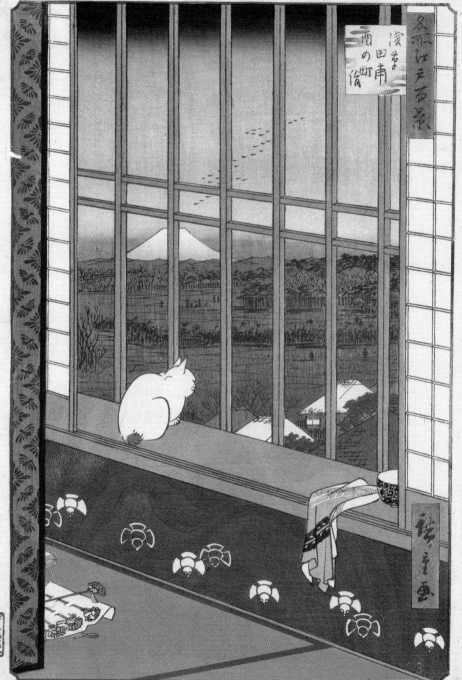

1st

2nd

3rd

4th

5th

6th

7th

The Book of Common Prayer and administration of the sacraments Undated, Oxford.

This is possibly an Italian 18th-century binding of white silk Damask, with a large flower embroidered in coloured silk and metallic thread on both covers, and another embroidered flower on the spine. The binding has been removed from its original text block, and re-used on this modern edition from Oxford University Press.

8th

9th

10th

11th

12th

13th

14th

The Tales of Ise *(Ise Monogatari)* Late 16th century, Japan.

The 10th-century literary classic, *Tales of Ise*, combines poetry and prose to document the pursuits of the courtier Ariwara no Narihira (825–880) This illustrated version is a fine early example of the genre known as *Nara ehon* ('Nara picture books'). It includes all 125 episodes alongside illustrations rich in vibrant orange and green tones and ornamented with gold.

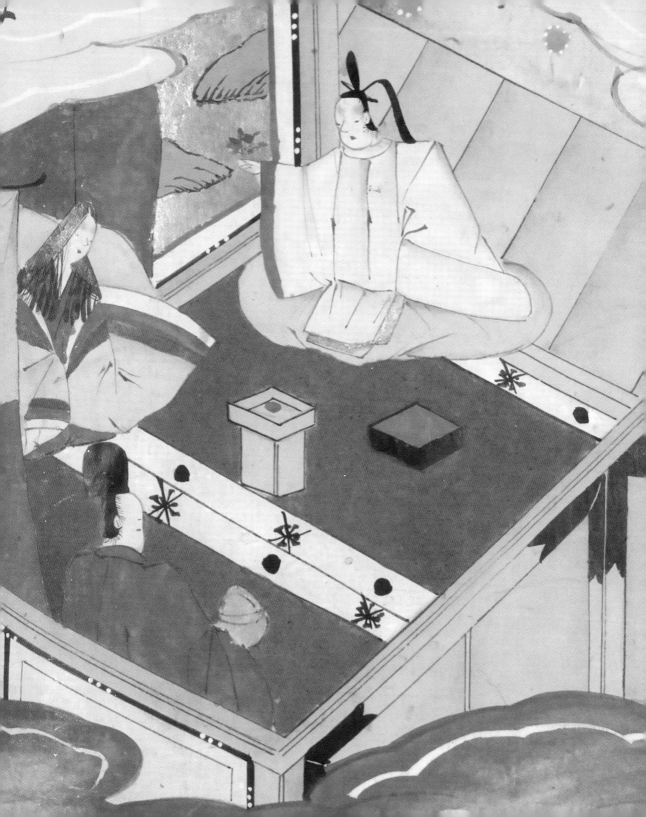

November ❋ Samhain

15th

16th

17th

18th

19th

20th

21st

One-half of a doublepage frontispiece, Juz 10 Illuminated by Muhammad ibn Aybak ibn Abdallah. 1305, Iraq. Chester Beatty was renowned for his refined and discerning taste, and he took care to purchase only the best material available. Beautifully illuminated manuscripts, albums and scrolls make up much of his collection. This folio is from the Islamic Collections and Islamic manuscripts are renowned for their copious use of gold, most often in conjunction with a deep blue pigment made from ground lapis lazuli.

November ❈ Samhain

22nd

23rd

24th

25th

26th

27th

28th

Book of the Dead of the Lady Neskhons c. 300 BC, Egypt.

Placed with the body, the ancient Egyptians' *Book of the Dead* might be regarded as a well-travelled road map to accompany one on the daunting passage into the afterlife, setting out the stages and rituals in this journey. This section is a black outline vignette of one of the most important rituals Lady Neskhons had to overcome to achieve eternal life: the weighing of the heart ceremony. The heart was believed to contain a record of all the deceased's actions during life.

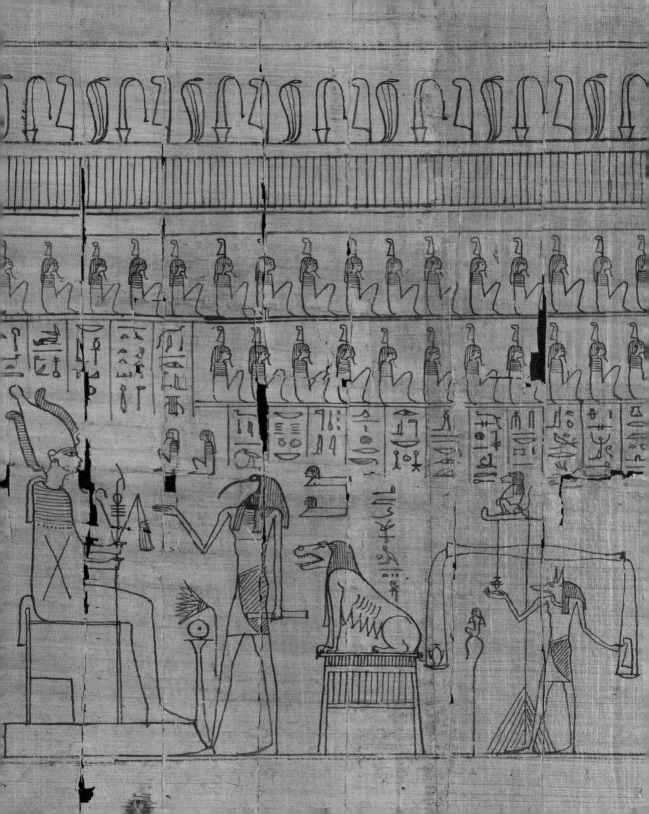

29th

30th

This month's memorable events

Snuff bottle 1750–1880, China.

Snuff bottles were among the earliest items collected by Chester Beatty. Many were acquired from dealers in New York, London and Paris, while others were bought by Beatty during his extended trip to Asia in 1917. In this example, the ice-cold clarity of the crystal is broken by a natural yellow inclusion, which has been cleverly manipulated to suggest the cloud base of the rising sun warming the group of three playful goats carved in high relief.

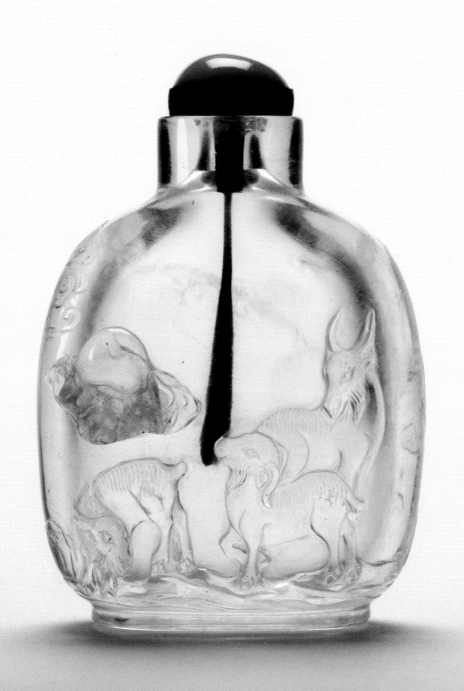

December ❈ Nollaig

1st

2nd

3rd

4th

5th

6th

7th

Homer's Odysseae libri XXIIII Translated by Raphael Regius; and **Ilias** Translated by Lorenzo Valla.
1541, France.

These two identically bound volumes contain Latin translations of Homer, published by Sebastian Gryphius (1493–1556), an early printer in Lyon, France and acquired by Chester Beatty in 1919. The books originally belonged to Thomas Wotton (1521–1587), one of the most important early English collectors of prestigious bindings. Wotton was described as 'a man of great modesty, of a plain and simple heart ... of great learning, religion and wealth'.

December ✳ Nollaig

8th

9th

10th

11th

12th

13th

14th

Chester Beatty walking along a Mont Dore street c. 1934 (postcard), France.

There are many letters in the Library's archives in which Beatty describes his trips to Le Mont Dore for 'the cure'. The clear, mountain air at this resort in central France was ideal for his respiratory ailments. In this postcard to his brother, William Gedney (in New York), Beatty wrote: 'Dear Will, This is the great shopping street in Mont Dore. No chance to find any manuscripts. Aff[ectionately] yours, Chester'.

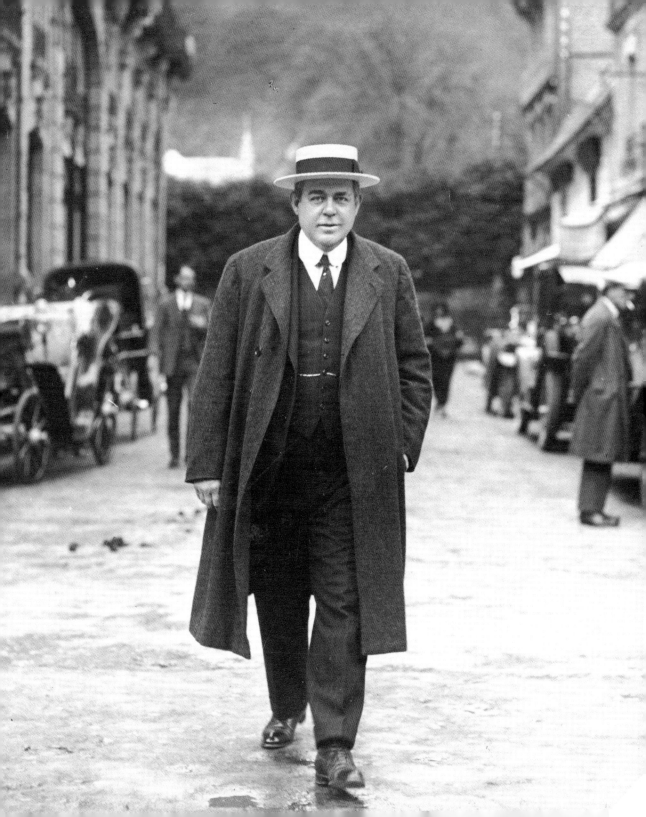

15th

16th

17th

18th

19th

20th

21st

Evangeliarium of Santa Giustina By Benedetto Bordon (c. 1450–1530). 1523–25, Padua.

The Nativity is the first of 75 illuminations in the *Evangeliarium* and is signed 'Benedictus Bordo' on the antique slab in the foreground. The Paduan-trained artist delighted in painting both landscapes and classical decoration. Here he combines the two elements in an elaborate visual play on a miniature scale. The Virgin Mary and Saint Joseph kneel in adoration of the Christ Child in front of a suitably rustic stable that houses an ox and ass.

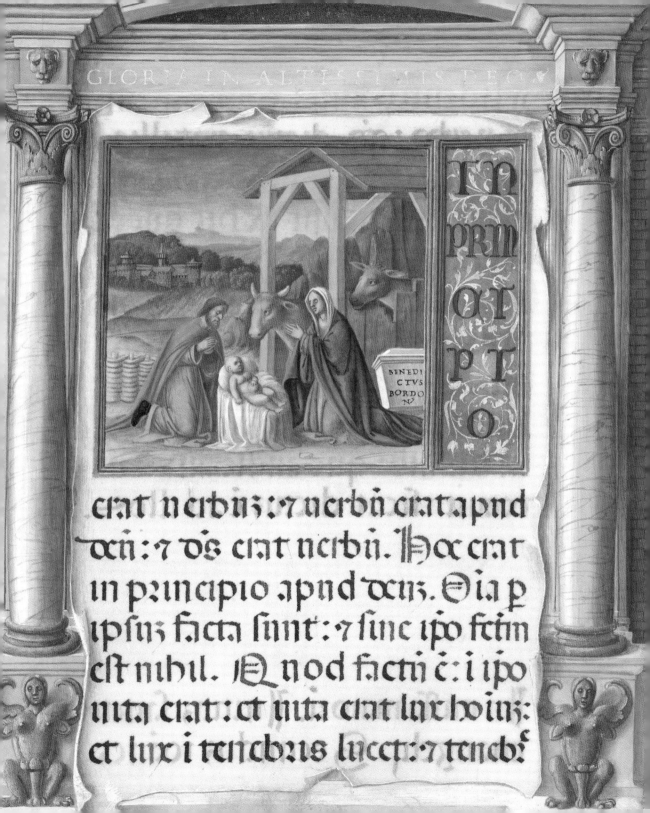

IN
PRIN
CI
PI
O

BENEDI
CTVS
BORDO
N

erat uerbn: 7 uerbū erat apnd
dcn: 7 ds erat uerbū. Hoc erat
in principio apnd den. Oīa p
ipsū facta sunt: 7 sine ipo fctm
est nihil. Qnod facti c: i ipo
nīta erat: et nīta erat lux hoīng:
et lux i tenebns lucet: 7 tenebf

22nd

23rd

24th

25th

26th

27th

28th

Virgin and Child (from *Rosarium* of Phillip II of Spain) By Simon Bening (c. 1483–1561). c. 1530, Belgium.
Simon Bening was one of the most celebrated painters in Flanders and was regarded as the greatest master of illumination in all of Europe. He specialised in Books of Hours but also produced genealogical tables and portable altarpieces on parchment. He was taught by his father, the painter Alexander Bening, and later served as dean of the Guild of Saint John and Saint Luke in Bruges. His daughter, Livinia, became court painter to Edward VI of England.

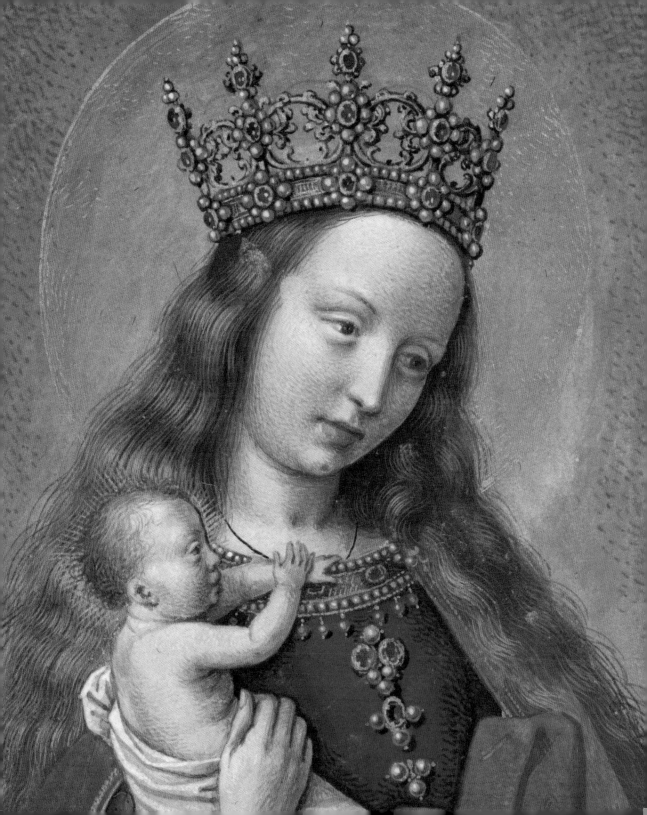

December ✻ Nollaig

29th

30th

31st

This month's memorable events

Atagoshita and Yabu Lane (from the series One Hundred Famous Views of Edo) By Utagawa Hiroshige
(1797–1858). 1857, Japan.

Hiroshige brought together elements from Japanese, Chinese and Western art in his work. He was particularly
skilled at conveying the atmosphere of climate, season and time of day. The series, *One Hundred Famous Views
of Edo*, includes landscape and genre scenes of the shogun's capital, Edo (modern Tokyo).

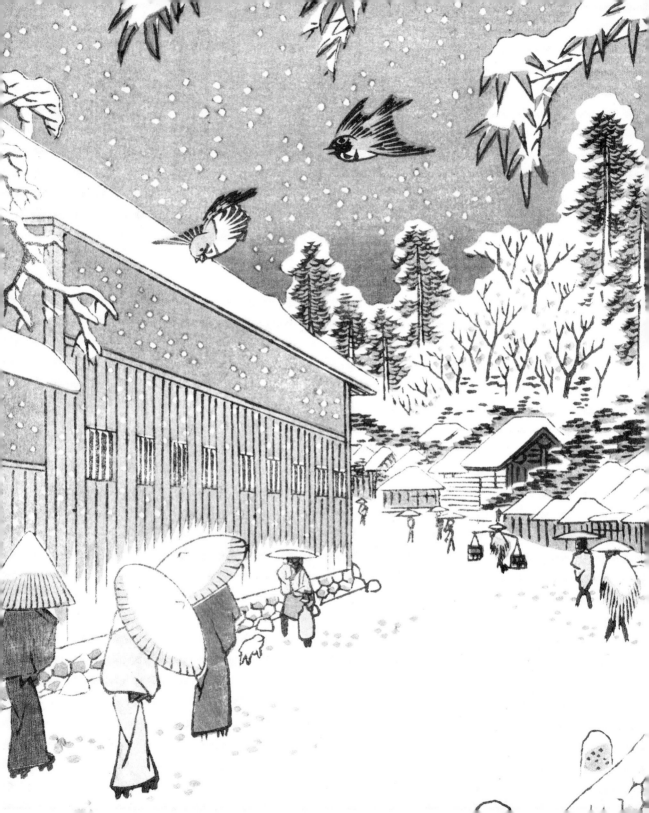

List of works

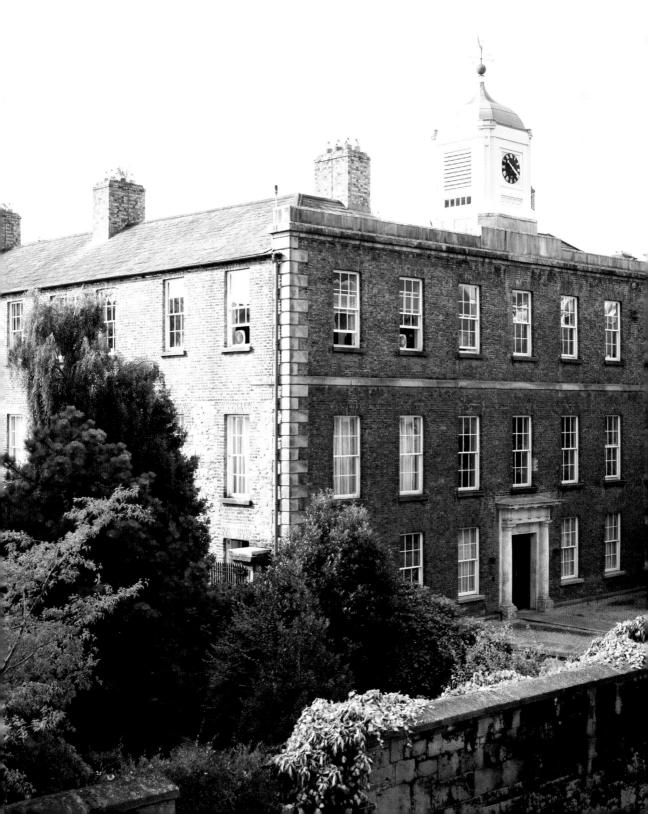

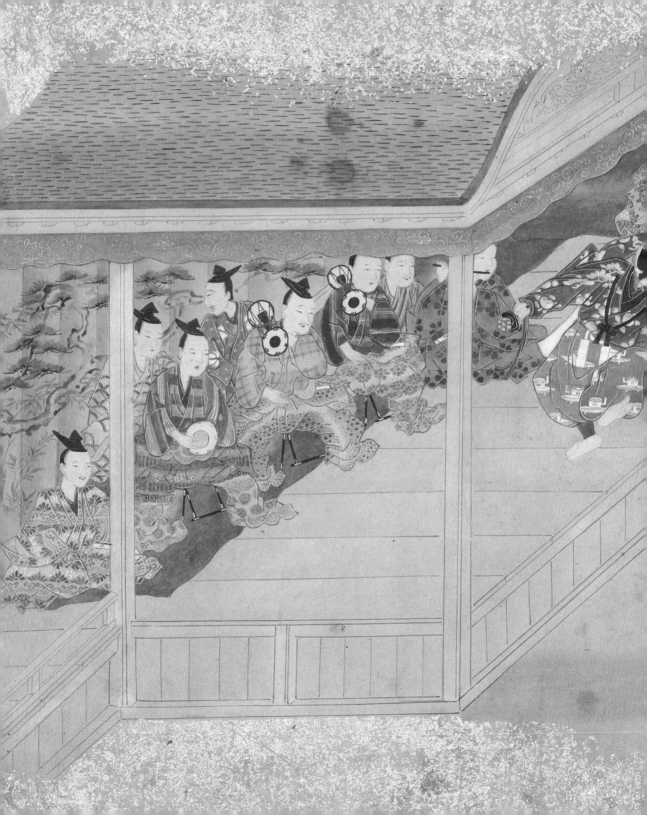